AIRBRUSH PAINTING

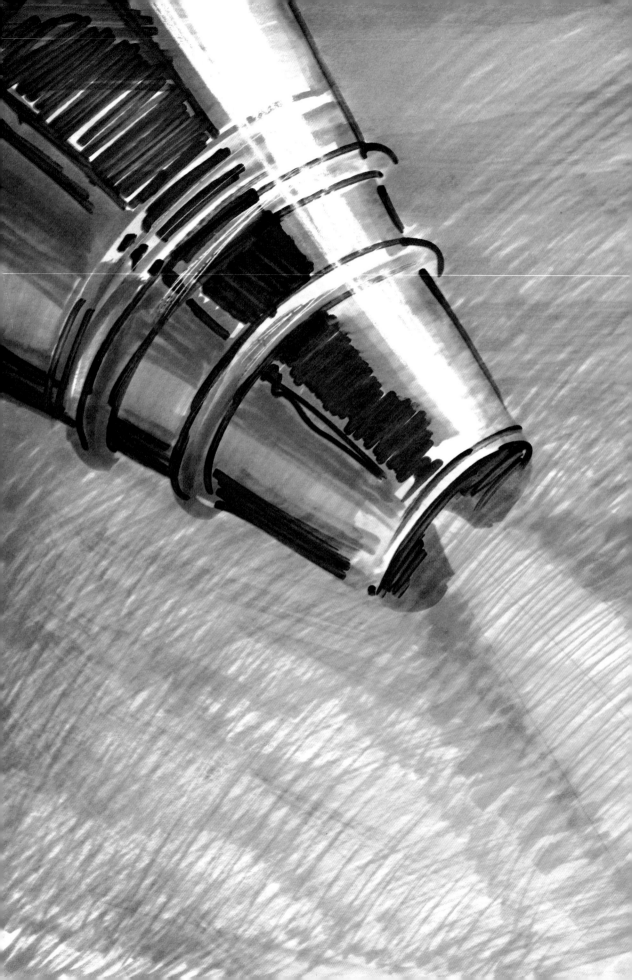

AIRBRUSH PAINTING

Miquel Ferrón

Watson-Guptill Publications/New York

Copyright © 1988 by Parramón Ediciones, S.A.
Published in 1988 in Spain by Parramón Ediciones, S.A.,
Barcelona

First published in 1989 in the United States by Watson-Guptill
Publications, a division of Billboard Publications, Inc.,
1515 Broadway, New York, New York 10036.

Library of Congress Cataloging-in-Publication Data

Ferrón. Miquel.
 [Así se pinta con aerógrafo. English]
 Airbrush painting / Miquel Ferrón.
 p. cm. — (Watson-Guptill artist's library)
 Translation of: Así se pinta con aerógrafo.
 ISBN 0-8230-0168-7
 1. Airbrush art. I. Title. II. Series.
NC915. A35F4713 1989 89-5813
 751.4'94—dc20 CIP

Distributed in the United Kingdom by Phaidon Press Ltd.,
Musterlin House, Jordan Hill Road, Oxford OX2 8DP

Manufactured in Spain by Sirven Gràfic
Legal Deposit: B.21.062-89

1 2 3 4 5 6 7 8 9 / 93 92 91 90 89

Contents

Introduction

Some years ago, I had the opportunity to teach drawing and painting at the celebrated Massana School in Barcelona. Founded at the beginning of the century, it has been attended by many famous artists and teachers, including Europe's premier ceramist, J. Llorens Artigas, who worked together with Joan Miró on the ceramic murals decorating the UNESCO building in Paris.

Drawing, painting, and applied arts—ceramics, mural painting, enamel work, graphics, etc.—are taught at the Massana School. The school is located in a Gothic building in Barcelona and is attended by over 2,000 students. Miquel Ferrón, the author of this book and a good friend of mine, teaches life drawing and painting classes at the Massana School. He is an excellent artist with a thorough knowledge of drawing techniques and a great talent for watercolor painting, oil painting, colored-pencil painting. . . . He also knows how to give a class, correcting and teaching thirty or forty students while they are drawing or painting a nude. It is fascinating to see Miquel Ferrón working with his students: imagine a large classroom with fluorescent lighting illuminating the students' work and two tungsten lamps lighting the model. And imagine an almost religious silence broken only by the sound of the charcoals being applied to the paper, and by Miquel Ferrón's low voice—a deep, calm voice—saying, "No, no. You should balance the tones.

Look, this is the darkest area and this one is the brightest. You should try to get the intermediate tones and. . . . " But apart from being a teacher and an artist, Miquel Ferrón is a consummate graphic arts professional—he is the art director at Prisma, an advertising and commercial art firm that specializes in design and graphics. Ferrón is an acknowledged expert on the subject, and a master of all graphics methods and techniques. Airbrush is one of them. "Drawing or painting with the airbrush," Ferrón says, "is not more difficult than painting with a brush or drawing with a pencil. In both cases, the problem is to know *how to paint* and *how to draw*. The rest is just a question of method. The only way of learning the method is through practice." This is the author, and this is the book. Written and illustrated as if it were one of Miquel Ferrón's classes, it is a visual book in which "nothing is expressed in words when it can be shown in images." Its progressive teaching allows the mastery of techniques from the basic to the most advanced, with exercises illustrated step by step to demonstrate all aspects of airbrush work. In Miquel Ferrón we have an excellent artist and an excellent author. And from him a good book, the one you hold in your hands.

José M. Parramón

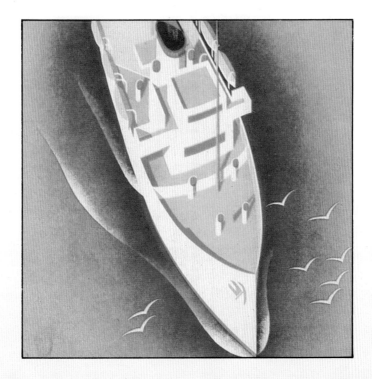

THE HISTORY
OF AIRBRUSH
PAINTING

Poster by Charles Angrave, 1932.

The airbrush, as it is known today, is probably the most perfect and sophisticated instrument for the spreading and pulverizing of colors with maximum precision. The earliest extant examples of this technique go as far back as prehistoric man, who, despite very primitive methods, achieved true airbrush effects. In the cave paintings of Lascaux (France), it is possible to find many instances: hands painted in negative, probably rendered by spraying colored pigments over the hand through primitive implements, such as a cane or a hollow bone.

The airbrush as it is known today was invented less than 100 years ago, in 1893, by Charles Burdick, a watercolor painter. Undoubtedly he was looking for a faster method that would allow him to give a more delicate finish to his works and solve the problems of rendering grays and graduated shadings that appear as halftones in backgrounds (e.g., in skyscapes).

At the beginning of this century, the airbrush was used almost exclusively to retouch photographs—increasing definition, contrast, and light and shade effects in general. The first important airbrush works appeared in the thirties—advertisements, magazine illustrations, and posters designed by such pioneers in the technique such as Bayer, Masseau, McKnight Kauffer, Cassandre, Brodovitch, and Petty, who thus revolutionized graphic communication.

But it was in the forties, during the Second World War, that fullest use was made of the airbrush, when the optical illusion of the third dimension became a popular way to attract the attention and awaken the interest of a society traumatized by the horrors of war.

When the war ended, the use and popularity of the airbrush inexplicably declined, and it once again served primarily in the retouching of photographs and as an auxiliary tool in the making of book and record covers. A paradoxical exception, however, was its increasing use in cartoon and science-fiction film productions.

The rediscovery of the airbrush took place in the sixties, when art, music, fashion, and culture in general looked for and adopted new ideas. Graphic communication also needed a new means of expression, and the airbrush offered some solutions to these artistic concerns.

Other names burst onto the panorama of airbrush creation: Michael English, Willardson, Charles White III, Philip Castle, and Peter Sato head the long list of artists who pushed the use of the airbrush to its highest limits.

Today, the airbrush is not limited to photographic retouching or graphic design, but is applied very successfully in other media. Some painters use it simply to improve the technical aspect of their work. In the film industry, the contribution of the airbrush has been decisive, especially in making models and filming very complex space-adventure productions.

There is no doubt that the use of the airbrush has advanced greatly since the time of Charles Burdick. Although the airbrush has often been criticized, more and more artists admire its possibilities and profit from them.

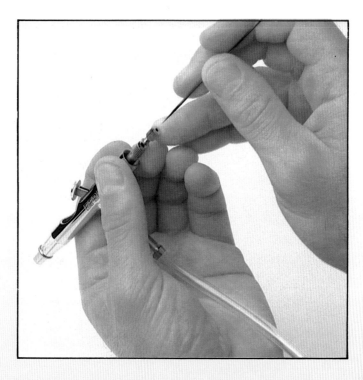

EQUIPMENT

Components of the Airbrush

Basically, the airbrush has not undergone many changes since its creation. Its design has been modernized and made more aerodynamic, its finish more perfect and luxurious, but the basic structure of the main components (such as the lever that operates and precisely directs the air that sprays the liquid color through the needle valve) already existed in the first airbrush created by Burdick in 1893. Before purchasing an airbrush, you should know that there are three main types of internal-spray airbrushes:

single-action airbrushes
double-action airbrushes
independent double-action airbrushes

The characteristics of each are as follows:

Single-action airbrushes are those that control the air and paint-flow rates by means of a button that operates the air intake. It is not possible to adjust either the velocity or the quantity of liquid in these models, but they give excellent and very exact results and are well-suited to beginners.

Double-action airbrushes are models with more possibilities; they are operated by a lever, and the intensity of air and paint may be adjusted jointly. They are highly precise instruments, practical, and recommended both for professionals and for beginners with a little experience.

Independent double-action airbrushes are the most versatile and sophisticated; they allow the artist to select the volume of air and the quantity of paint separately. It is the most common type of airbrush on the market and, because its operation is a little complicated, is mainly for experienced professionals.

All the models on the market have various nozzles that range from a fine, 0.15 mm size for high precision work to large openings ideal for applications to extensive surfaces.

Manufacturers offer a wide choice of high-quality instruments for all types of professional needs. The Japanese brand Rich Pen and the prestigious German brand EFBE produce a large range of airbrushes, from precision pencils to models with a capacious color jar for large works. Other countries, such as the United States and England, offer such reliable brands as De Vilbiss, Thayer & Paashe, Olympos, and Badger.

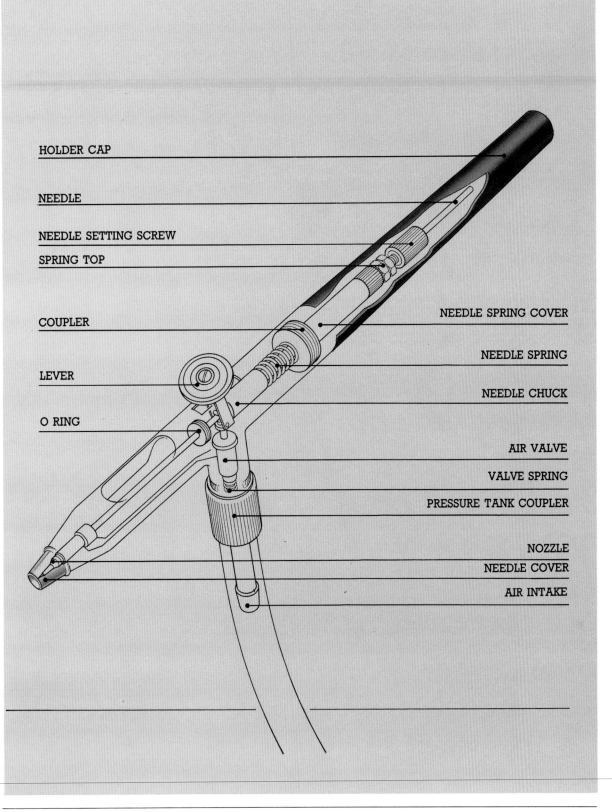

HOLDER CAP

NEEDLE

NEEDLE SETTING SCREW

SPRING TOP

COUPLER

LEVER

O RING

NEEDLE SPRING COVER

NEEDLE SPRING

NEEDLE CHUCK

AIR VALVE

VALVE SPRING

PRESSURE TANK COUPLER

NOZZLE

NEEDLE COVER

AIR INTAKE

Types of Airbrushes

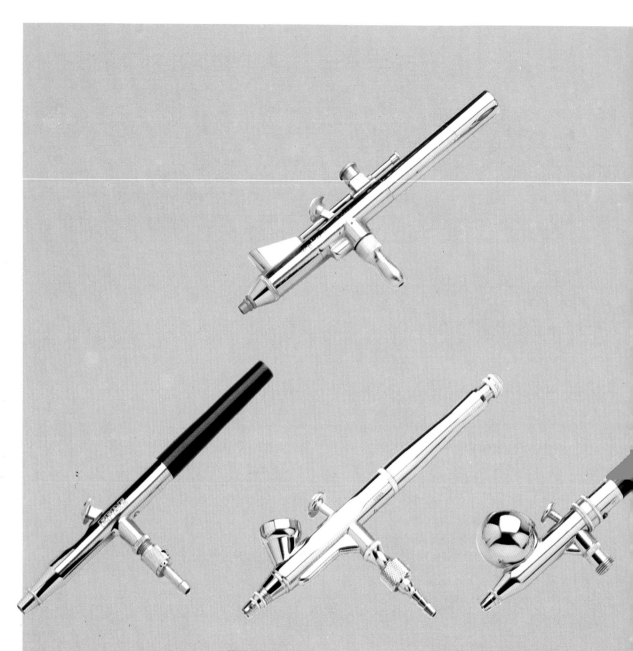

WOESSNER
Model FOTO double-action airbrush. Various interchangeable nozzles sized from 0.2 mm up. Color jar capacity: 1.5 cc.

EFBE
Model A double-action airbrush. Nozzle size 0.15 mm, for high precision work.

RICH PEN
Model 212 B double-action airbrush. Nozzle size 0.2 mm, for very exact work.

DE VILBISS
Model SUPER 63 independent double-action airbrush. Nozzle size 0.15 mm for work requiring maximum attention to detail.

HOLBEIN

Model Y-3 independent double-action airbrush. Its 0.3 mm nozzle allows a wide range of possibilities. Color jar capacity: 7 cc.

EFBE

Model C-1 double-action airbrush. Its 0.3 mm nozzle is suitable for all types of work, from the most exacting to the covering of large areas. Color jar capacity: 6 cc.

.BADGER

Model 200 single-action airbrush. For work that does not require precise detail.

WOESSNER

Model MAYOLICA double-action airbrush. It has interchangeable nozzles ranging from 0.2 mm to 1.2 mm; large color jar capacity to facilitate the painting of large surfaces.

Air Supply

Until quite recently the only valid air supply systems for airbrushes consisted of large, noisy, and expensive compressors (smaller ones existed but were much less reliable) and heavy air cylinders that were difficult to transport and required constant refills.

At present, modern, absolutely silent, small and easily transportable compressors are an excellent alternative to these problems. The constant airflow, free of fluctuations, guarantees perfect airbrush work. The size and capacity of these devices will depend on the number of airbrushes that they have to feed; in order to prolong their service life, it is recommended that they not be overloaded.

In any case, the purchase of a modern compressor is still a major expense, even though it is the most economical long-term solution. The maintenance costs are minimal, and there is no need to be continually changing cylinders or cans of compressed air. Manufacturers of these components constantly seek to perfect their products, so interesting and progressive innovations can be anticipated.

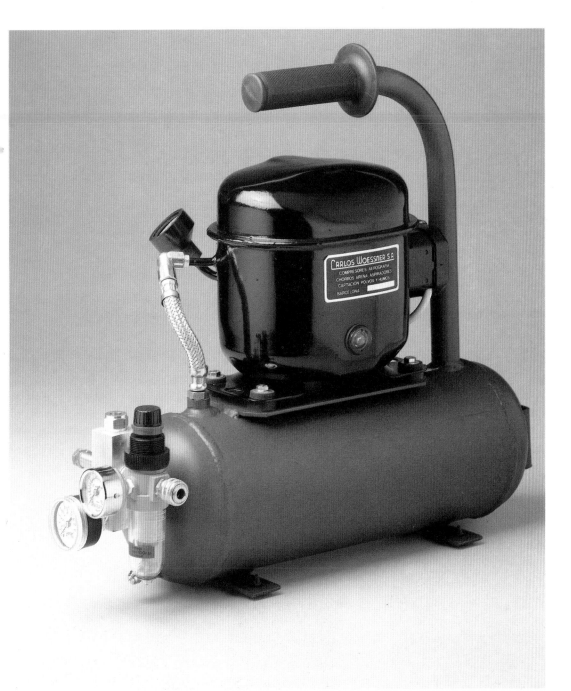

WOESSNER
Compressor model CW-S,
fitted with a piston motor.
It gives a pressure of up to
8 bars and an airflow of 15
liters per minute. Reservoir
capacity: 5 liters.

Air Supply

Compressed Air Cylinders

Compressed air (CO_2) cylinders have, for many years, been the most popular way of supplying air to airbrushes. Artists prefer them for their technical and functional advantages over old compressors. These had a continuous airflow, without fluctuations, that was adjustable by means of a control valve; their operation was totally silent and they did not need any electricity. Their greatest disadvantage was, and still is, that they run out suddenly (a problem easily solved by the incorporation of a level indicator); once empty, the cylinder must be replaced. There are, however, medium-size cylinders that are very manageable and well-suited to certain types of graphic work.

Compressed Air Cans

A relatively new product, a can of propellant is very suitable as an introduction to the use of the airbrush, as a complement to inexpensive systems, or in cases where airbrush work is sporadic or does not require great precision.

The main disadvantages of compressed air cans are their reduced capacity and their gradual loss of pressure, with a consequent negative effect on the final result of the work.

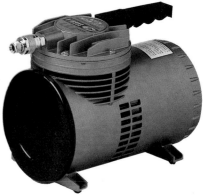

SAGOLA
Compressor model 777, fitted with a diaphragm. It provides a pressure of 3 bars and an airflow of 450 liters per minute.

COMPRESSED AIR CAN
Loaded with 500 cc of propellant.

COMPRESSED AIR CYLINDER
Fitted with a control valve and with a capacity of 5 kg of CO_2.

Compressors

There are compressors with reservoirs, without reservoirs or direct action, with pistons, with diaphragms; there are even silent ones. The artist has many choices. The range of accessories and components for an airbrush is also very wide: regulators, purifiers, filters, control valves, etc. The aim of these accessories is none other than the improvement of less expensive units.

RICHCON
Compressor model KS-707 T, fitted with a 450 cc capacity reservoir. It produces an airflow of 10 liters per minute at a pressure of 2.4 bars.

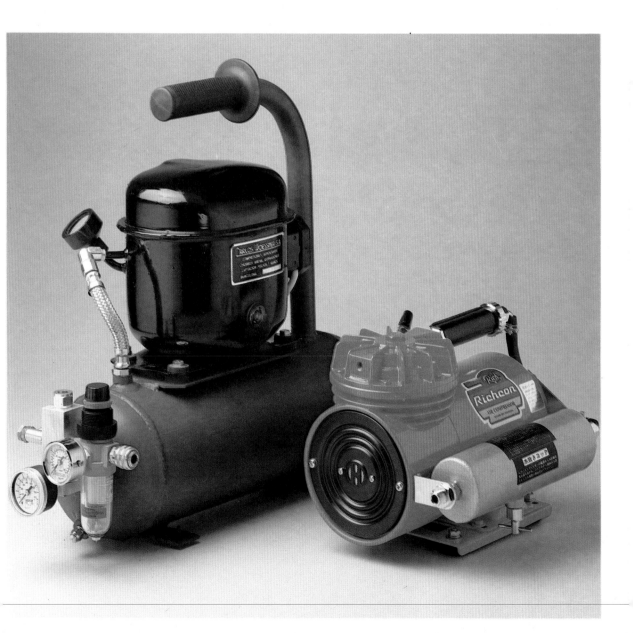

Other Accessories and Tools

Creativity is not the only factor that will lead to a good final result in a work. The artist must also know the importance of various tools that will lead to a perfect finish. These are such things as stencils, cutters, masking systems, and materials for basic retouching and special effects. With practice, the artist will discover and investigate methods and tricks to produce his creation. Air masking, spattering, and decoloring methods are just a few of the technical challenges you will encounter.

The photograph shows examples of some essential basic materials. Later, examples and exercises will show their practical applications.

MASKING PAPER

TRIANGLES

CENTIMETER RULER

ADHESIVE TAPE

CUTTER

SURGICAL SCALPEL

BRUSH

ERASER PENCIL

ERASER

SPRAYER

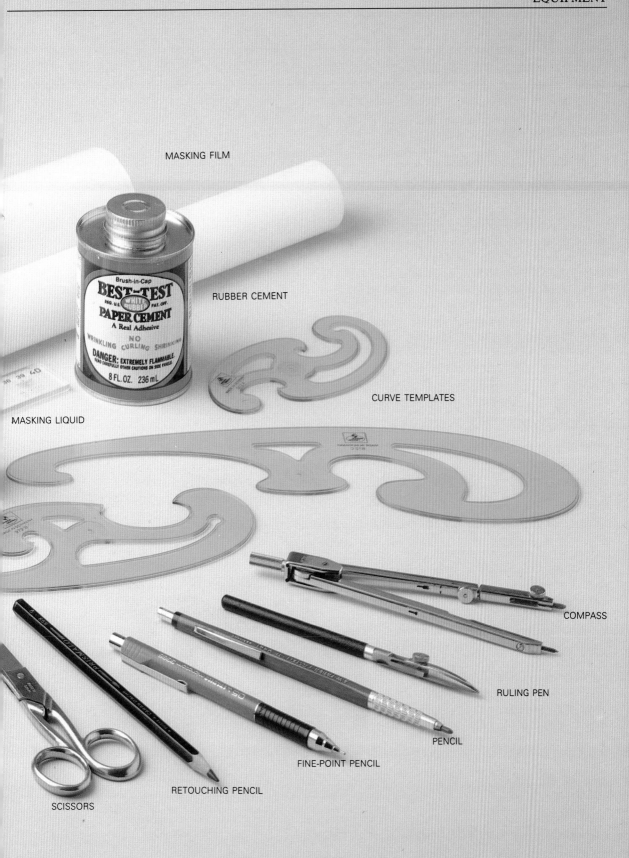

MASKING FILM

RUBBER CEMENT

CURVE TEMPLATES

MASKING LIQUID

COMPASS

RULING PEN

PENCIL

FINE-POINT PENCIL

SCISSORS

RETOUCHING PENCIL

Colorants

Inks and watercolors

Liquid inks and watercolors are especially suited to transparent airbrush work. In order to get pastel tones that cover well, white must be added. With transparent colorants different intensities are easily achieved by applying several coats or adding more color to the darker areas.

Some pigments, due to their consistency and specific composition, must be diluted with distilled water. This means that all tools, especially the airbrush, must be thoroughly cleaned in large quantities of water or even alcohol before the color has time to dry out and clog the apparatus.

Liquid watercolors are less solid but not less intense. They can be dissolved in plain water, so cleaning the airbrush is easy.

Gouaches

For airbrush work, it is advisable and even necessary to use very diluted gouache colors so that the nozzle is not blocked. The greatest difference between gouaches and other colorants such as inks or liquid watercolors is that they cover much more quickly.

Gouache is ideal for covering large areas where uniformity is required, and also for retouching photographs.

Acrylics

Acrylic paint used in airbrush work is usually diluted in water, although some brands are diluted in special liquids (thinners).

When using acrylic paints, a clean airbrush is absolutely necessary, and it must be rinsed with water or special solvents (thinners) designed for this purpose. If these precautions are not taken, a very hard film will form as the paint dries, and this film could cause serious damage to the airbrush.

The airbrush is usually associated with smooth, minutely finished surfaces. This calls for—almost demands—the use of satin-finish papers with little or no grain.

On the other hand, the airbrush is a liquid medium, a technique that really wets the paper, causing waves and wrinkles that make the even application of color, the use of stencils, and the drawing of forms and outlines difficult if not impossible. It is therefore necessary to work with thick, heavy paper or bristol board, or better yet, with mounted and stretched paper.

SYNTHETIC-HAIR BRUSHES Nos. 2, 4, AND 8

SABLE BRUSHES Nos. 00, 1, AND 3

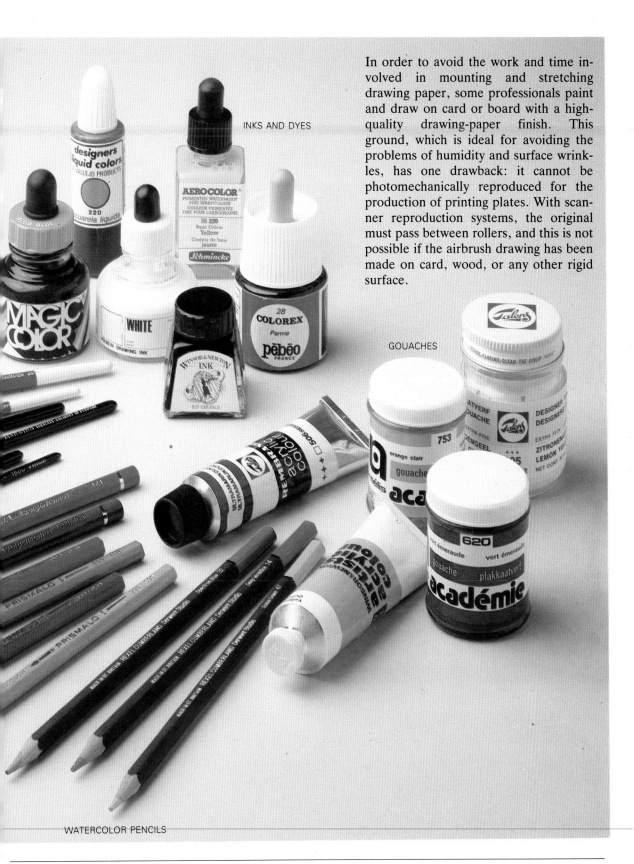

INKS AND DYES

GOUACHES

WATERCOLOR PENCILS

In order to avoid the work and time involved in mounting and stretching drawing paper, some professionals paint and draw on card or board with a high-quality drawing-paper finish. This ground, which is ideal for avoiding the problems of humidity and surface wrinkles, has one drawback: it cannot be photomechanically reproduced for the production of printing plates. With scanner reproduction systems, the original must pass between rollers, and this is not possible if the airbrush drawing has been made on card, wood, or any other rigid surface.

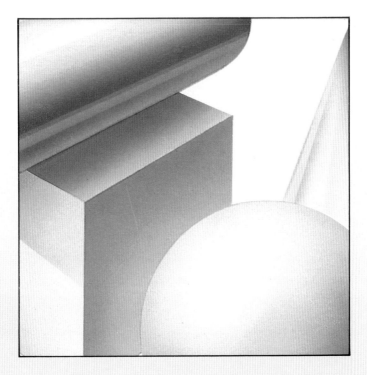

–USING–
THE AIRBRUSH

Care and Maintenance of Airbrushes

The life of an airbrush depends on the care given it. It is absolutely necessary that it be kept perfectly clean. It is, as you know, a very delicate precision tool, and any knock or bump could cause damage. Water is best and most efficient for cleaning the airbrush. However, if other non-water-based colorants, such as oils and special acrylics, are used, the airbrush must be thoroughly rinsed with the appropriate solvent or thinner before being rinsed with large amounts of clean water.

It is also important to operate each type of airbrush always at its most suitable pressure. This pressure is usually from 1

1 Before manipulating the needle, remove the rear part or airbrush handle, and loosen or unscrew the locking nut.

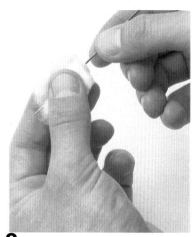

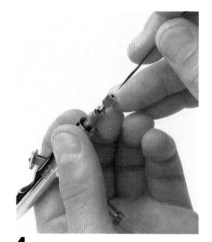

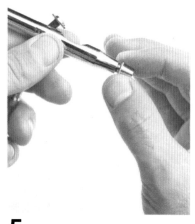

3 Very carefully remove the needle and clean it with a damp piece of cotton. Use extreme caution, as any violent movement could bend the needle and unbalance the precision of the spray.

4 Be very careful not to damage the needle when replacing it in the body of the airbrush. This is the most delicate moment in the entire cleaning process.

5 To clean the nozzle, unscrew the needle retainer, making sure that the needle is pulled back; this avoids causing any damage to the point.

to 5 bars, depending on the model. It is always advisable to work at a standard pressure of 2 to 3 bars.

One last piece of advice: any mechanical problem with the airbrush should be referred to an authorized technician.

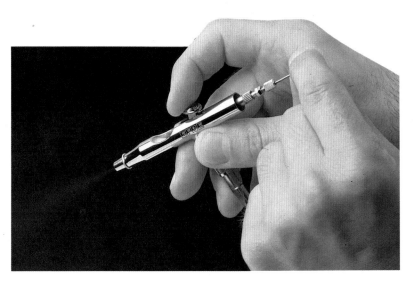

2 Fill the color jar with clean water. Operate the finger lever to move the needle forward and backward until the spray, tested on any surface (paper, newspaper, rag, etc.), is free of all color. Do this several times.

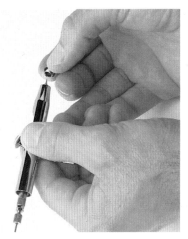

6 After using the airbrush, always fix the needle by tightening the retaining screw.

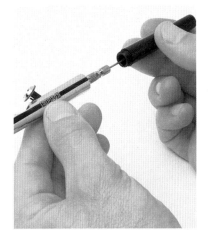

7 When the airbrush is not in use, protect it by replacing its cap. If this cap is not in place, any accidental fall could irreparably damage the instrument.

8 It is essential to keep the airbrush in a good container. Make sure that everything that comes into contact with the airbrush is completely free of foreign bodies that could cause damage.

Problems: Causes and Solutions

As the airbrush is a precision instrument, it can present innumerable operational problems. A professional knows these problems and can solve most of them, but beginners can be surprised indeed by unexpected errors or faults. The following table offers solutions to some of these problems by explaining their causes and possible remedies.

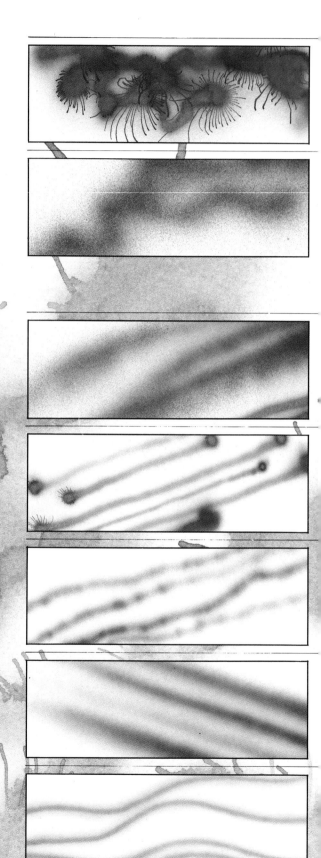

Problem	Causes	Solutions
Blots form.	The medium is too watery. The airbrush is too close to the paper. The needle is drawn in too far.	Thicken the color. Move the airbrush until the pressure on the paper is correct. Set the needle in place and adjust it with the screw.
Splashing.	There is not enough air pressure. The paint is thick and badly mixed. There are particles of pigment in the nozzle or the body of the airbrush. Paint has accumulated in the nozzle. The nozzle is damaged.	Correct the air pressure. Empty the airbrush, clean it, and remix properly. Dismantle the airbrush and clean it properly. Draw the needle back and clean the nozzle thoroughly. Replace it.
Splashes and deviations in the line.	The needle is twisted.	Straighten or change the needle.
Splashing at the beginning and end of the line.	The main lever is releasing too fast and producing an accumulation of paint.	Release and press the lever more gently.
Irregularities in the line.	Lack of confidence in handling the airbrush. Obstruction in the nozzle.	Practice to achieve greater dexterity. Clean it thoroughly.
The line is too broad.	The needle is worn out. The nozzle or the cap is not in place.	Replace it. Adjust them as necessary.
Fine lines are fuzzy.	The needle is either worn out or twisted.	Straighten or change the needle.

Problems: Causes and Solutions

Problem	Causes	Solutions
The main lever does not return to its position after use.	The valve spring is not tense enough. The main lever is broken.	Adjust or replace the valve spring (professional repair). Professional repair.
The needle is getting blocked in the body of the airbrush.	The paint may have dried inside it. The airbrush has been mistreated.	Dip the airbrush in water and unblock the needle carefully. Professional repair.
The paint flow is interrupted.	The paint is too dense. The needle is too tightly adjusted. Not enough paint is in the reservoir. The main lever is broken. Dried paint is blocking the nozzle.	Dilute the paint as necessary. Set the needle in place and check the screw. Fill the reservoir. Professional repair. Dismantle and clean the nozzle and needle.
Too much pressure is in the air.	The air pressure control is too high.	Reduce the pressure.
Air escapes through the nozzle and there are bubbles.	The nozzle cap is either loose or not properly placed. Insufficient air supply.	Adjust the nozzle. Increase the air pressure.
Air escapes when the airbrush is not in use.	The air valve rod is badly adjusted or the diaphragm is broken.	Professional repair.
Air escapes through the main lever.	The air valve rod or the diaphragm is broken.	Professional repair.
Air escapes through the supply source joints.	The joints are loose or damaged.	Adjust or replace the joints.

Basic Techniques

Mastering any technique always requires study. In the case of the airbrush, such study is even more important because operating this instrument is somewhat complicated.

The airbrush is not so very different from a good paintbrush, so if you have had a lot of practice with a brush—above all for straight lines or curves, or even for backgrounds—the use of the airbrush will be much easier.

In general, the airbrush must be held with maximum freedom, balanced on the curve of the hand between the thumb and first finger. In this way, the whole hand, except the first finger, which controls the air lever, can hold the airbrush comfortably.

The exercises that follow will allow you to discover some of the many possibilities of this fascinating instrument.

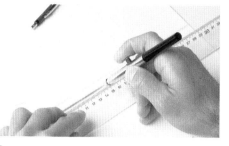

1 A STRAIGHT LINE
Practice drawing lines from right to left by resting the airbrush on the raised edge of a ruler.

2/3 CURVES/CIRCLES
Try to maintain a constant movement in the desired direction. Curves are more of a wrist movement than circles, which involve a movement of the whole arm.

4 A DOT
Hold the airbrush over a point of the paper and carefully press the lever; the closer the airbrush is to the paper the smaller the dot will be.

5 OVERALL FLAT BACKGROUND
The airbrush must be held 10 to 15 cm (4 to 6 in.) from the paper. Open the needle valve so that the spray covers a wider area. Move the airbrush from right to left and back again, being careful not to create a buildup of color on the edges.

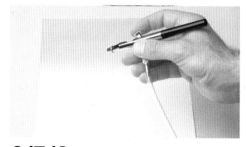

6/7/8 FADING WASHES
Follow the same process as in the previous exercise but put more color on the areas shown in the illustrations. Fade from dark to light and horizontally.

9 FLAT MASKING
Cut a piece of paper to the desired shape and fix it to the surface to be sprayed, using an adhesive or weights.

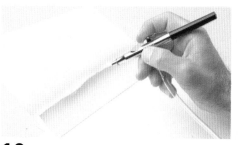

10 RAISED MASKS
In order to get a more diffuse edge, the mask has to be raised from the ground. This mask must be made of thicker paper or card so that air pressure and humidity do not alter the shape in any way.

lighter paper will give harder or softer edges. Cotton gives the softest edge of all.

12 LIQUID MASKING

In order to achieve a negative effect, the ground must first be protected. For this purpose there are various types of liquid latex masks that are applied directly with a brush or pen. Once the area has been sprayed, this mask is removed by rubbing it with a rag or latex ball. The negative effect appears immediately.

11 RAISED MASKS/TORN EDGES

In theory, any type of torn paper appears as is shown in the illustration. However, heavier or

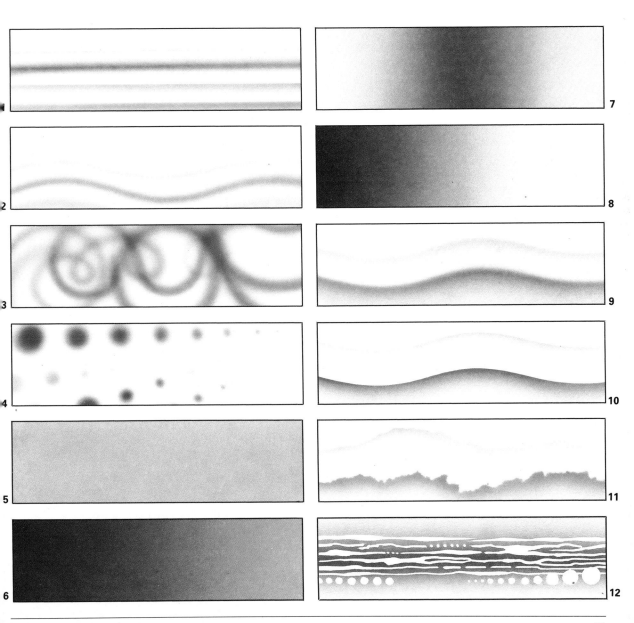

The Cube

If we look around us we will realize that everything has a basic structure that can easily be reduced to such simple forms as a cube, a cylinder, or a sphere. We are now going to begin a series of practical exercises, starting with the different three-dimensional effects of these basic shapes. In the case of the cube, for example, our aim will be to get a three-dimensional effect from the perspective of the faces and the effects of light and shade. We will use middle tones, diluted in water to get a light shade that will be strengthened according to the density needed.

Masks

The masks used will also be very simple. There are three planes, and it is necessary only to establish the order in which each is to be painted (1, 2, and 3 in the diagram) to create lighter and darker areas by masking and unmasking according to this order.

1 We begin the exercise by placing the three masks that form the cube on our ground. We then unmask the upper part (1) and spray lightly from right to left, and a little more heavily in the upper corner.

2 We once again cover the area of mask 1, uncover that of mask 2, and apply a uniform base tone.

3 We now cover the area of mask 2, uncover that of mask 3, and spray a uniform gray tone.

4 We once again uncover area 2, and, masking the rest, apply a soft fade from the lower-left-hand corner toward the center of the area. This is done over the previous base tone.

5 Covering area 2 and uncovering 3, we darken the area with an intense gradation from the uppermost central corner down. This will give us good contrast, highlight the central edge, and push the rear part of the cube further away, that is, heighten the three-dimensional effect. The exercise is now finished.

The Sphere

Unlike the figures studied up to now, the sphere is much more complex than it first appears. As there are no angles on the surface, shading is always done freehand and in the form of a circle. This means that we must have good freehand control and be able to carry out the wrist and arm movements easily.

The shadow will be in the lower right-hand area, and we must strive to create a volume with smooth characteristics and avoid any uncontrolled hardness. The airbrush control lever must be operated with great care.

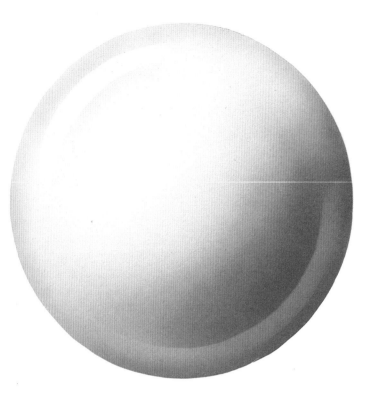

1 The mask is cut and placed on the drawing paper; a first circular coat is applied with a slightly increased intensity around the edge of the sphere.

2 We have already decided that the light will strike the upper left-hand part of the object. We must therefore darken the opposite side, the lower right-hand area, in order to achieve the desired effect of volume. The shading is soft and made with an oscillating movement following the form of the sphere.

3 We continue by repeating the previous step and so build up the intensity of the shading. The spray is applied in the same way as before, and care taken not to stop the movement of the airbrush, as this would produce unwanted blots.

Masks

In order to airbrush a sphere we use three masks: two circular ones (Figures A and B) and one with the special shape shown in figure C.

4 Without removing the previous mask, we add the second mask to reduce the radius of the sphere, keeping the counter-mask for later use. Covering the central part of the sphere, we slightly darken the upper left-hand area. Now uncovering the central part, we use the counter-mask to highlight the lower right-hand area with a darker tone.

5 An excellent three-dimensional volume has been achieved. However, in order to give more realism to the sphere, we will use a small mask and an eraser to produce a highlight by placing a little white patch on the base tone. The exercise is now complete.

The Cylinder

In the cylinder, as in any other geometric form, light will play the main form-giving role in the representation. In this case let us imagine that the light falls on the upper part of the figure. Consequently the darker tones are in the lower part. This same criterion is used to show the inside of the cylinder.

At first the gradation will be very diffuse, and go from darker to lighter. Later, highlights will be added to give the idea of a metallic shine and a greater plastic beauty to the figure. Just as for the cube, the ideal colorant will be middle-toned ink, diluted in water.

Masks

Once the diameter of the cylinder has been decided, two basic masks are made—the inside and the outside of the cylinder. The order in which these masks are applied depends on the surface to be covered. That is, the larger exterior area is done before the interior. A simple mobile mask is enough to obtain the metallic effects that we are striving for.

1 After establishing the general mask, we will begin by uncovering area 1, which will be given a base color that is slightly more intense in the lower area than in the upper part. The work of creating volume is thus begun.

2 After remasking the previous area, we now uncover area 2 and apply a downward gradation with the area of greatest intensity in the upper part. This will give the sensation that the cylinder is a hollow tube.

3 Steps one and two are repeated to build up the illusion of three-dimensional volume.

4 With one or more very simple straight masks (3), we retouch the first area with various tones so that the shape acquires a shine. With an eraser and a stencil, we create a reflection in the upper part to give it a metallic quality.

5 The second area requires the same treatment as the first. With this the exercise is finished.

The Cone

The cone is a geometric shape very similar to the cylinder, the one difference being that the light and shade effects converge toward the apex. We therefore follow the same process as for the cylinder, but this time the light will be on the left-hand side and the shadow on the right. Shading must be from dark to light in a circular or cylindrical direction, and the shadow given greater density on the outside edges. Some reflections and shine will be added, using the same colorant as in the preceding figures.

Masks
The only mask needed for this figure must be exactly the same as the figure itself. Moving this mask from one side to the other is enough to achieve the effect of volume.

1 Just as for the sphere, we place the pre-cut mask on the ground and then paint in the background color, starting from each side and moving toward the center. We must be sure that the center is free of color.

2 The idea of volume is created by repeating this process a little on the left, and more intensely on the right.

3 By the use of masks made from a template like that of figure 2 (they can be straight strips of paper), we will try to build the idea of volume and shine through the application of differing color intensities.

4 We will then progressively define and highlight the various values.

5 After the final retouches with the airbrush, an eraser will once more aid us in defining the volume by bringing out some white areas.

Composition

We are now going to make a composite of the figures studied so far according to the methods established for the creation of these figures. This is not a repetitive and uninteresting exercise, but rather one that is a final practice of everything that has been studied up to now. It is well worth carrying out for various reasons: first, we will stimulate our sense of creation by placing the figures in harmony and balance; and second, we will be able to study the effect of light on the whole group, which is very different from that selected for each figure by itself.

The masking techniques will also be much more complex in this exercise, and therefore will form the bridge between these basic works and others to be undertaken in the future. The colorant will be ink, and we will use two tones so as to give the composition a greater plastic beauty.

3 Once the sphere is complete, it is masked and the airbrush cleaned. We will work with a different color for the cube and paint areas 1, 2, and 3 in that order.

Layout
The layout shows the composition we have chosen after studying and correcting the perspective and the shapes of the ellipses.

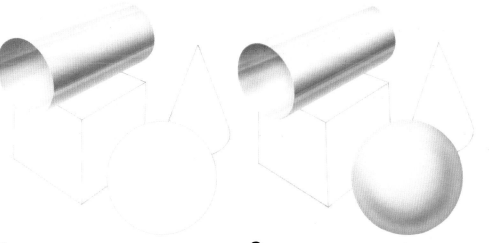

1 The whole composition will be protected by a general mask selected according to personal criteria. We will then uncover each of the figures and follow the steps outlined in the individual exercises. In this example we will begin with the cylinder.

2 We will then cover the cylinder and continue with the sphere; as it is the same color, we will not have to clean the airbrush. The effect of volume is created as in figure 2.

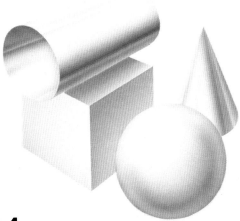

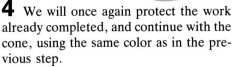

4 We will once again protect the work already completed, and continue with the cone, using the same color as in the previous step.

5 Finally, we will retouch some areas, creating shine by using the eraser and projecting a shadow onto the cube to give more realism to the whole group.

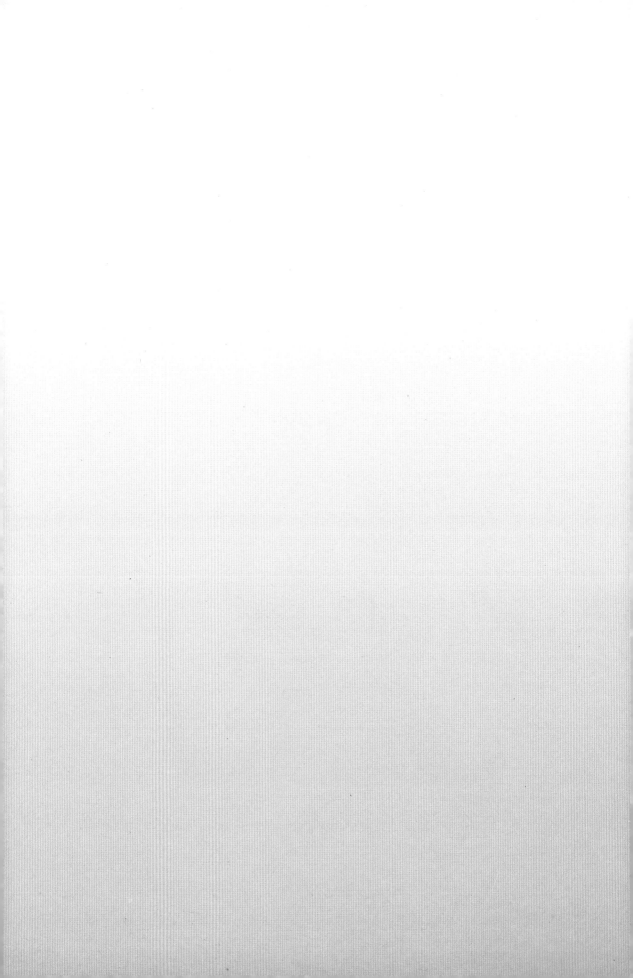

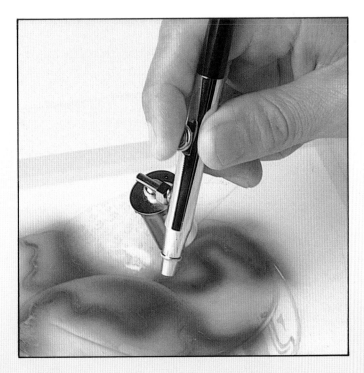

STEP-BY-STEP
DEMONSTRATIONS

Introduction

The following pages show a series of practical exercises, eight in all, together with details and a step-by-step explanation. The exercises are based on models or photographic references specially selected for this purpose.

These exercises are designed not to demonstrate the creative aspect of the images themselves, but rather to show the techniques and processes applied in each case to represent forms, values, volumes, textures, reflections, finish, and so on.

A Rose

This first exercise is ideal for practicing freehand airbrushing, as the background and a large part of the flower use this technique. To achieve the desired result we will use liquid watercolors. Their transparency will help create the soft appearance that this work requires.

With this, as well as with the majority of work to be done by airbrush, some previous studies and exercises are necessary to ensure a good final result. Also, we must remember that it is better to paint from light to dark, progressively increasing tones and colors.

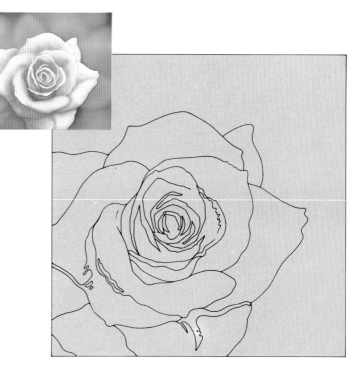

1 We begin by drawing all of the components of the flower with a hard pencil. We then place the general mask on our ground, and uncover the area to be painted by very carefully following the outline of the flower with a cutter.

2 In the background of the illustration we have to create the idea of diffuse or out-of-focus leaves. This is done by using an overall, medium-green tone. Raised masks create the leaves, and we use the airbrush progressively until the background is complete.

Using a more intense blue, we then airbrush in darker areas that highlight and give the final form to the background.

3 A

3 The background is then masked and we begin to develop the flower (3A). In some areas we must create the idea of intense light, doing so by using a liquid mask painted on with a brush (3B).

3 B

A Rose

4 We then use pink to provide the base color, trying to develop the first tints of three-dimensional volume.

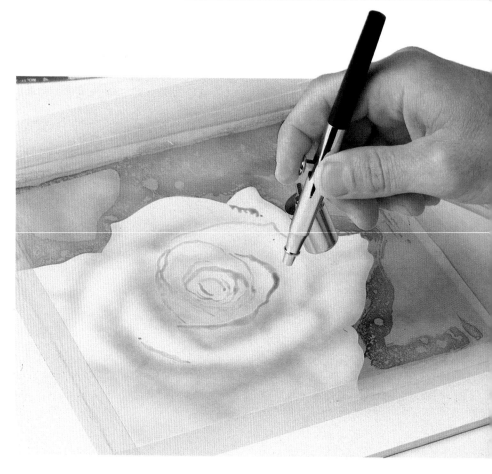

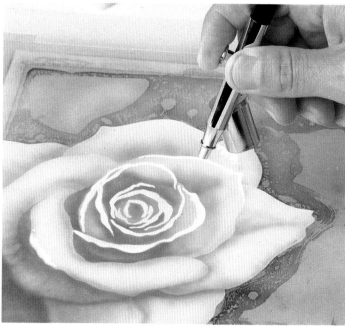

5 The liquid mask is then removed with an eraser, exposing the protected white areas. We use darker tones and masking to highlight and contrast the shape of the petals and to develop the volume of the whole.

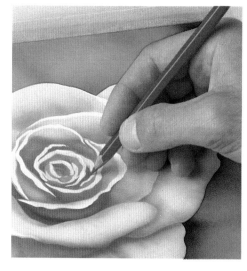

6 The final touches are too laborious to be done with the airbrush. Instead we use colored pencils to outline the petals and to bring out details.

7 The exercise is now finished.

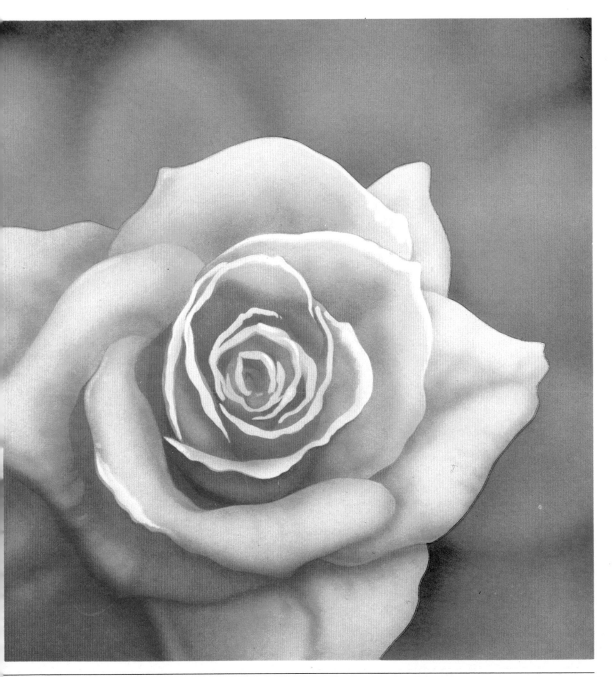

A Hand

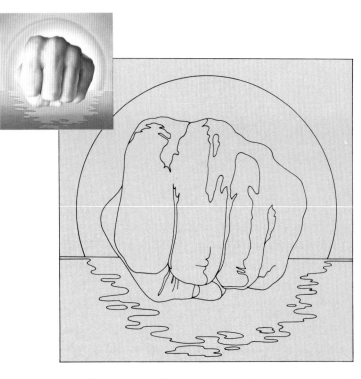

This exercise also provides practice in the freehand use of the airbrush. It includes the added difficulty of presenting a part of the human body with its corresponding problems of skin coloring, shape, anatomy, and light and shadow effects. In order to achieve a realistic representation of the anatomical structure and the color and shades of the skin, we will first make an in-depth study of this part of the body and try to assimilate its inherent peculiarities. The colorant to be used is liquid watercolor, which, as we have seen, allows us to create three-dimensional volume.

1 Once the masking has been removed from the area to be painted, we will use a raised mask to get a blended effect between two tones. Because this type of mask has to be durable, it is wise to use quite heavy card. We can use any flat object fixed to the back of the card in order to raise the base. Once the mask is adjusted and in place we can airbrush in the desired color.

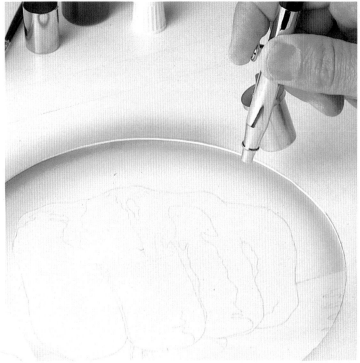

2 Using the counter-mask of the previous step, we then repeat the same operation, always using a circular motion to ensure a perfect stroke. We are now building up the sky in the background, and we will slowly achieve the desired mixing of the two colors.

3 Bearing in mind that the illustration has a very special background, we now begin to build this up, starting at the horizon. We once again cover the sky and then uncover each area and apply the color separately. The photograph shows the moment in which we are highlighting the color at the bottom of the illustration to gain a better plastic effect.

A Hand

4 Once the background has been painted, we cover it and then unmask the fist. Next the base color is applied and the illusion of volume begun, with special attention given to areas of light and shadow.

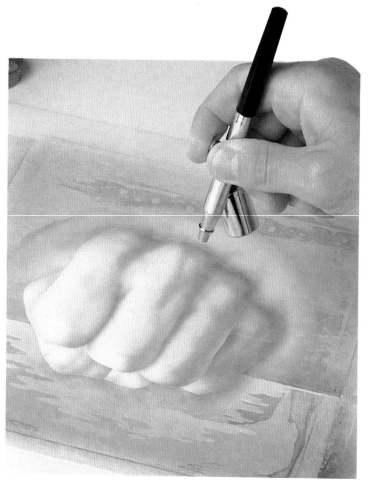

5 Using a darker skin color, we now paint the final contrasts.

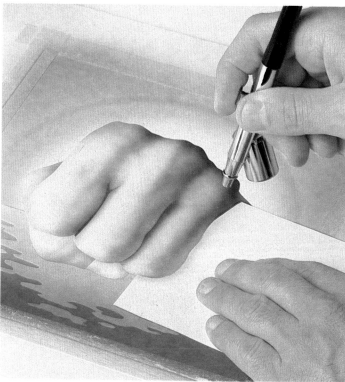

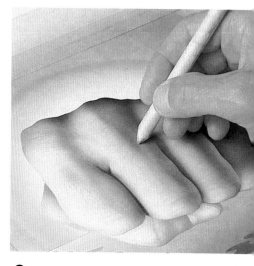

6 The small details and peculiarities of the texture of the skin are finished with colored pencils and shading. Some bright spots are then made with a knife, and a surprisingly realistic effect is achieved.

7 The finished illustration.

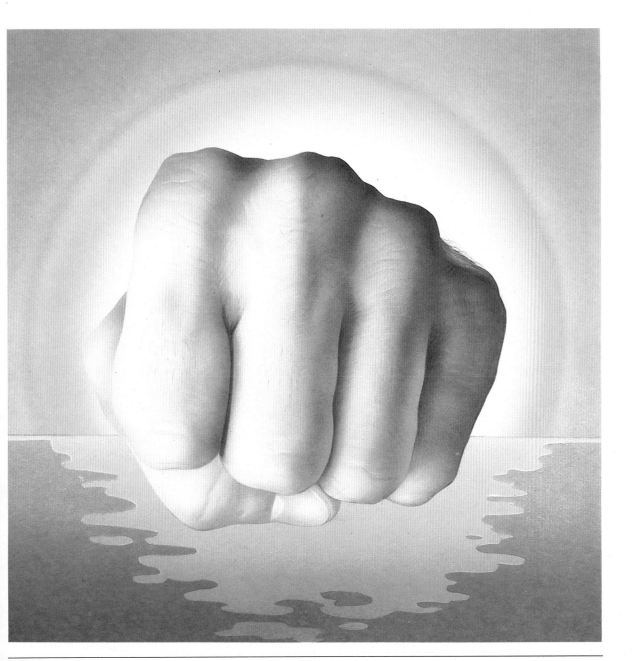

A Still Life

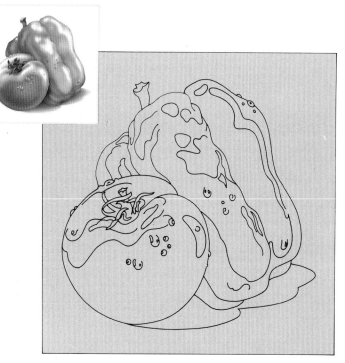

This is the classic exercise for the three-dimensional study of volume, and is particularly good for practicing freehand airbrushing. The previous studies of volume and highlighting are now combined, and, except for the masking of the background and the exact reproduction of the tomato and the pepper, our greatest concern is the precise application of color in the predetermined areas.

In this case we will also use liquid watercolors because of their transparency, and because they gain intensity as we highlight and outline areas.

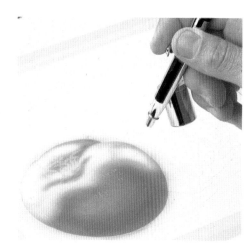

1 After masking the whole area, we uncover the tomato and use masking liquid to cover the points that will correspond to the shine, as well as those of the stalk and the leaves. We then airbrush in the red base and begin to build the form of the tomato. Keep in mind the area where the light is going to fall.

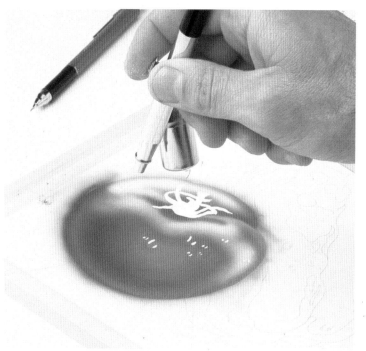

2 Using a darker color, we begin shaping the tomato until it reaches its maximum volume. It is now almost finished.

3 We next cover the tomato, uncover the pepper, and proceed as before, applying the basic color. In this case we use green and shades of red to create the effect of light and volume.

4 We proceed with the progressive application of green and red to give a final shape to the pepper.

A Still Life

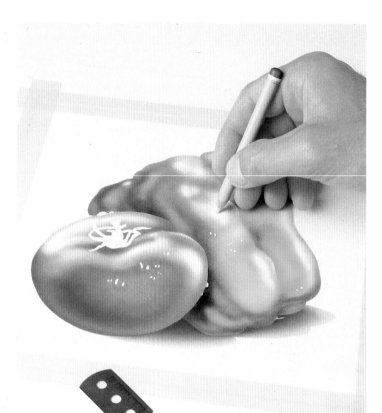

5 As we create the volume, the areas where the light falls receive much more color than necessary. We now clean these areas with an eraser to heighten the illusion of three-dimensional volume.

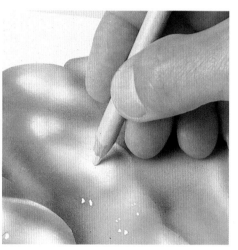

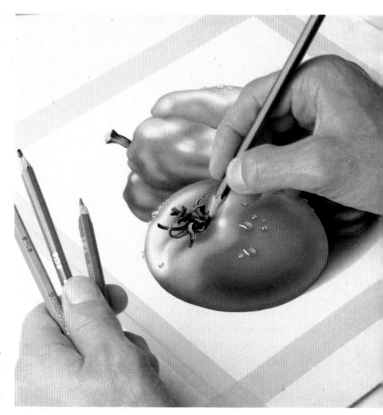

6 The final touches, such as drops of water and leaves, are applied with the aid of brushes and colored pencils.

7 The finished illustration.

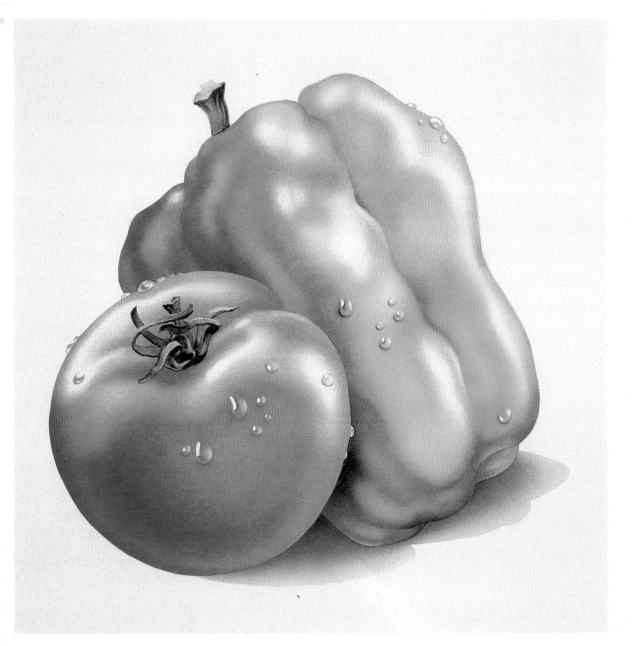

A Shoe

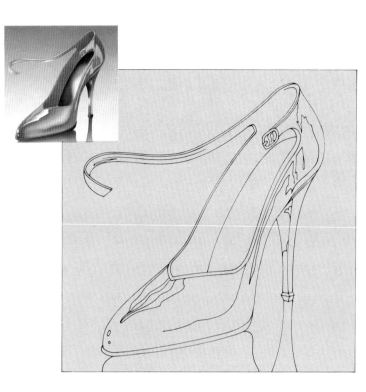

This exercise is very easy due to the simple, basic outline of the drawing. The greatest difficulty is in the study of the contrast between reflections and shine on the model. We will use liquid watercolors because of their transparency and brightness.

The main point of this exercise, apart from the perfection of the finish, is the care that must be taken in the combination of the different shades to achieve a convincing final result (see illustration).

1 We mask the general area of the drawing and carefully cut out the shape of the shoe. This is left covered and the background left exposed. The background is now filled in with a gray-violet color graduated from top to bottom with more intense coloring in the upper area.

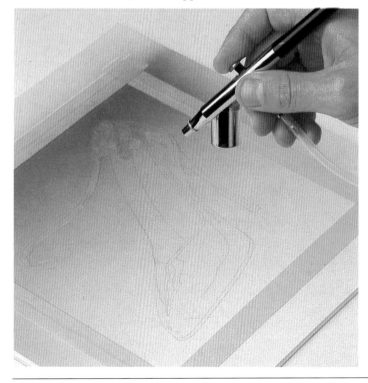

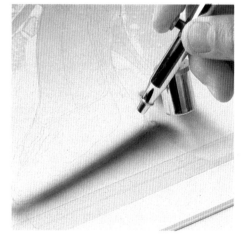

2 We now cover the background and paint the reflection of the shoe in a darker color (see the illustration at the top of the page opposite).

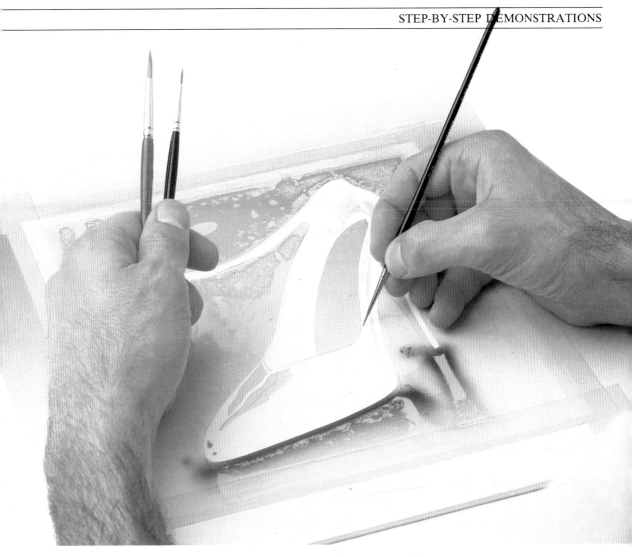

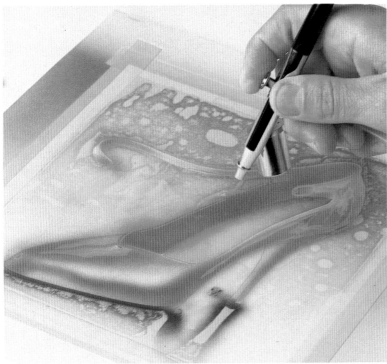

3 We once again cover the background, including the inside of the shoe, and apply masking liquid to create a glossy surface inside the shoe.

4 We now fill in the basic red of the shoe and begin to model its shape, including the illusion of volume and shine.

A Shoe

5 We next remove the masking liquid and uncover the areas we want to be glossy.

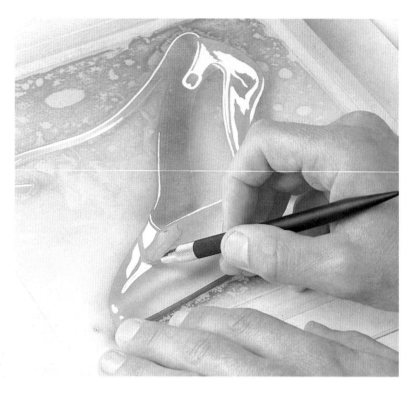

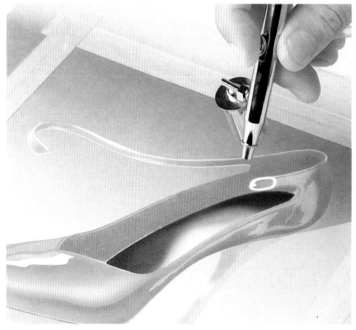

6 Using a lighter red, we now soften the hardness of the previous color, and, with a darker color, we bring out and perfect the final shape of the shoe.

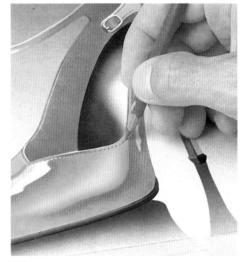

7 The only remaining work is to retouch and finish details such as the buckle and the seams. For this we will use a brush and colored pencils; a few white spots will be made with a knife.

8 The finished illustration.

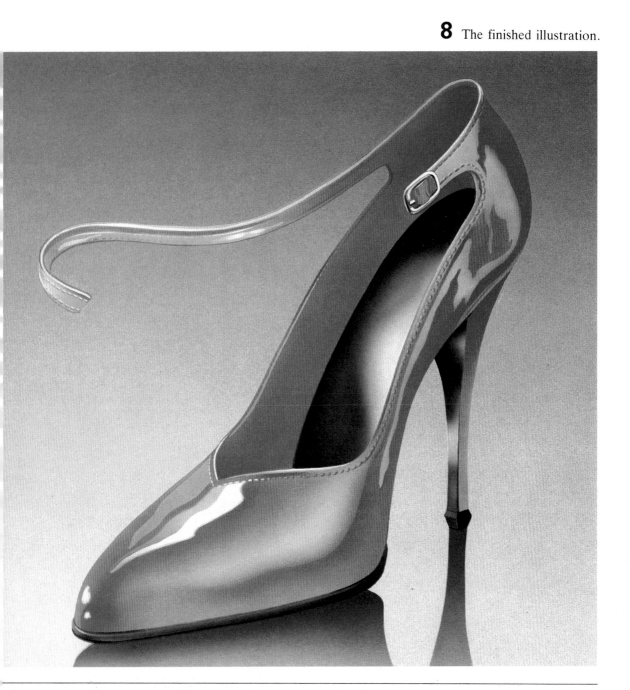

A Landscape

This exercise is ideal for those who are just beginning to use the airbrush because of the figurative aspects of the work. However, at the same time, it is interesting for its graphic aspects and the concrete shapes involved, which here play a secondary role to that of the light itself. Liquid watercolors and opaque pigments are used for special effects in the final stages. The masking provides a good field for experiment, as the final result is achieved through the use of ordinary cotton masks and liquid reserves.

1 The first step is to determine the shapes and colors of the sky and the water. Both the clouds and the rays of sunlight have to be masked, but not in the same way. The rays of light will be covered with masking liquid and the shape of the clouds delimited with cotton. Latex-based glue is used, as it can be removed later with ease.

2 A soft blue is used as the basic color and its intensity is increased in the upper part of the image.

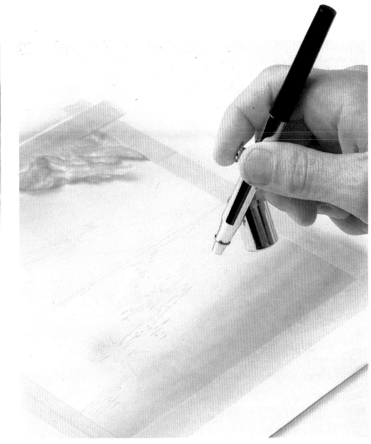

3 As for the water, darker areas are left in the foreground.

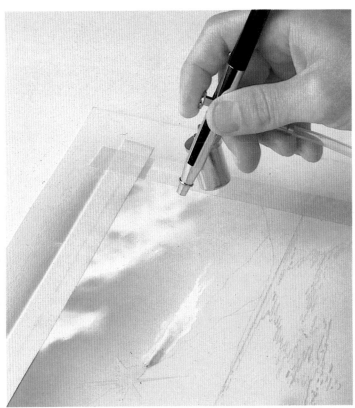

4 Once the cotton mask for the clouds is removed, the effect is just as we expected; now some gray must be added to give form and consistency to the clouds.

A Landscape

5 A general mask now protects the finished part of the image. Masks for the outline of the mountains and their reflections in the water are now cut, and a more intense color is applied to these areas.

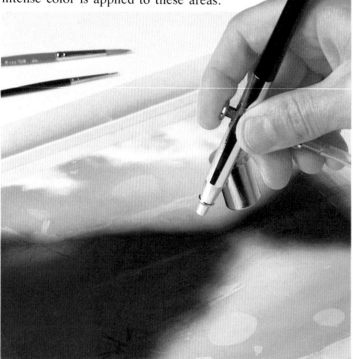

6 The same operation is repeated for the mountains in the middle ground and their reflections in the water. This gray color is also used to enhance the suggestion of soft waves in the water in the foreground.

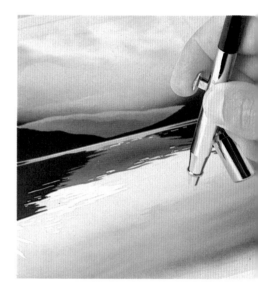

7 The rays of sunlight, covered until the last moment, are now exposed and shaped with a knife. Note that masking liquid is generally removed with an eraser or by rubbing with a finger, except in cases like this, when it must be removed with a knife, as the masked area is within a zone already painted with the airbrush. Opaque gouache is now applied in order to achieve the soft glow that gives more richness to the drawing.

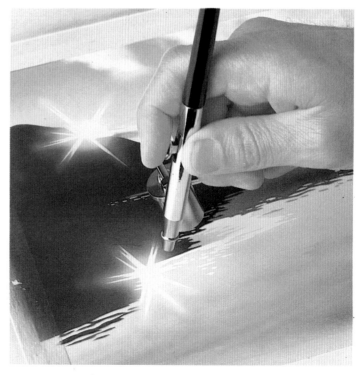

8 The finished illustration.

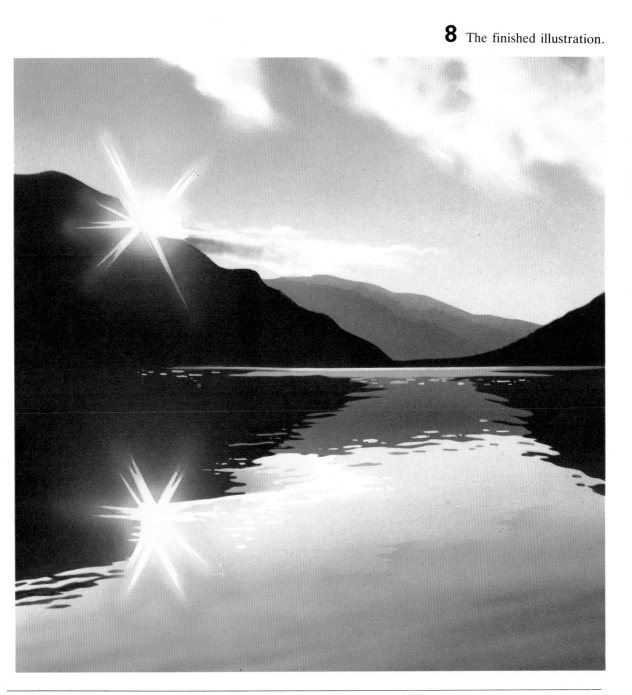

A Car

This exercise gives us the opportunity to experiment with the shine of the metallic surfaces of a car, its chrome areas, its volume, the effect of light and shade—all the aspects that correspond to the mental picture we have of a car. In this exercise, the shine and reflections stress the importance of masks and their application. Note that this exercise will require a good deal of effort in the final stages to produce details in such areas as the chrome finish and the lights, which are executed without the airbrush. Liquid watercolors are used in the airbrush and gouache for the hand-painted details.

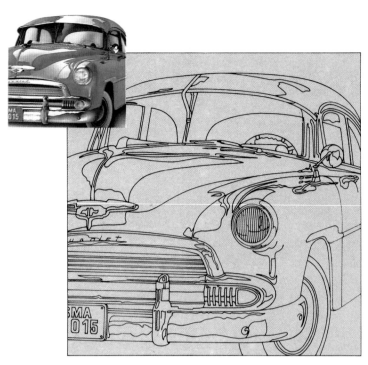

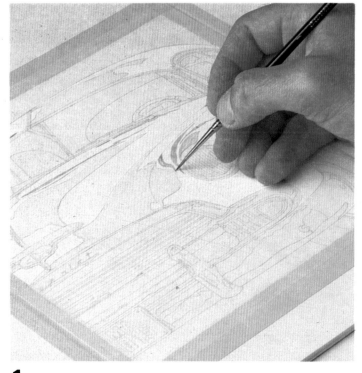

1 Once the whole surface has been masked, the areas of the chassis are then uncovered. The areas that will have only a small shine are masked by the application of masking liquid.

2 Airbrush in a suitable basic blue, highlighting the dark areas that will later create the illusion of volume.

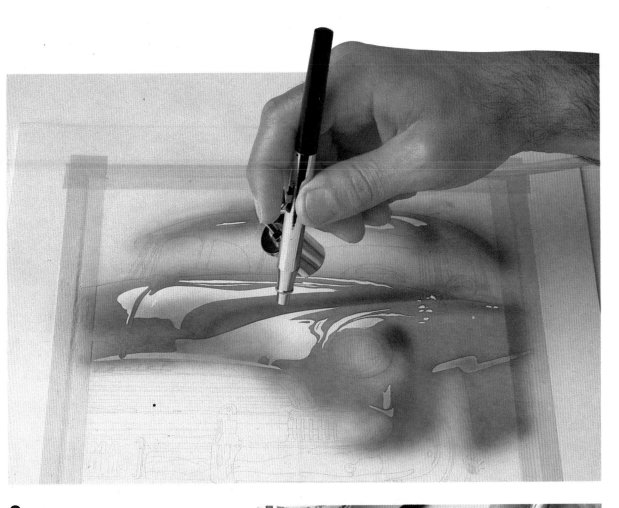

3 Uncovering the glossy areas, we apply a gray tone to the lower parts to represent the particular aspect of the shine on the body of the car.

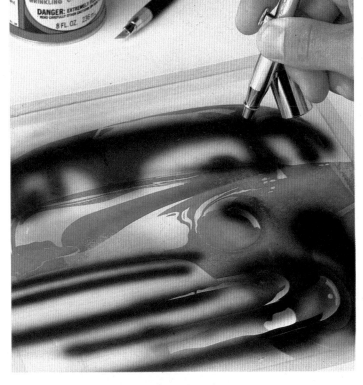

4 The body of the car is now covered, and the interior and the dark areas exposed to airbrushing in blue-black.

A Car

5 The front of the car is now unmasked, and the glossy areas covered with masking liquid.

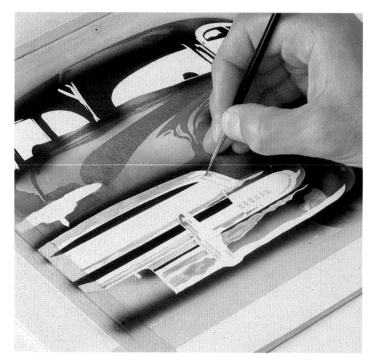

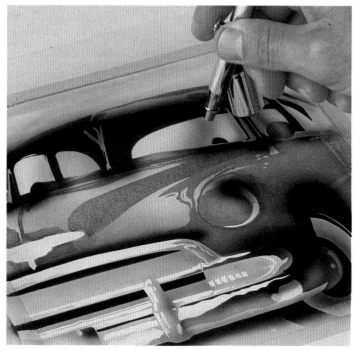

6 A middle gray tone is airbrushed on the metallic parts of the bumper, as well as on the wheel and on the glass of the windshield. This must be painted with a slight gradation to represent its reflection.

7 Because of all the details and outlines on the car, the finishing touches must be done by hand.

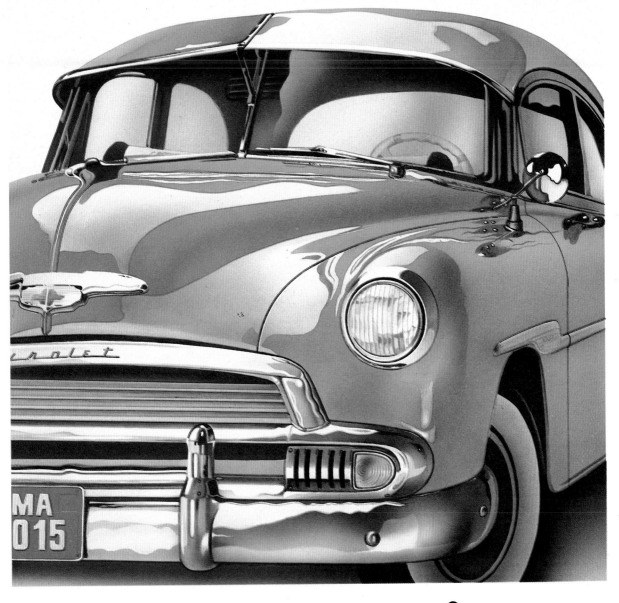

8 The finished illustration.

An Ice Cream Sundae

In this delicious little exercise, all our efforts will be concentrated on the problems posed by the special effects of the different textures involved. The exercise requires very careful study of the model; the transparency of the glass goblet, the textures of the ice cream and the strawberry, the gloss on the caramel, etc., will all be reproduced by different techniques. These and other peculiarities, together with the richness and brightness of the colors, provide a real challenge.

Liquid watercolor will be used in order to get better results in the transparencies and the glazes.

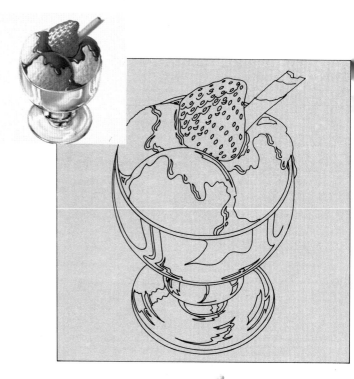

1 With the background protected by a general mask, the work on the glass begins. A series of shiny and reflecting areas are covered with masking liquid, applied with a synthetic-hair brush.

2 A soft gray is applied as a base, and the tones and colors of the goblet are begun. At the same time, care must be taken with the building of volume and transparency.

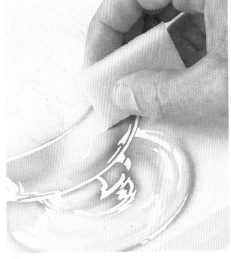

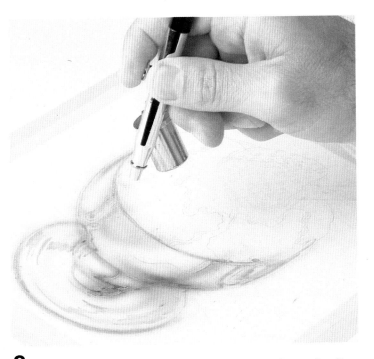

4 A crepe eraser (or a pencil eraser) is used to remove the masking. The gleam looks just as planned; the glass already appears transparent.

3 As the subject is ice cream, the transparencies and reflections must be soft and diffuse both in intensity and color. This creates the halo effect produced by its coldness.

An Ice Cream Sundae

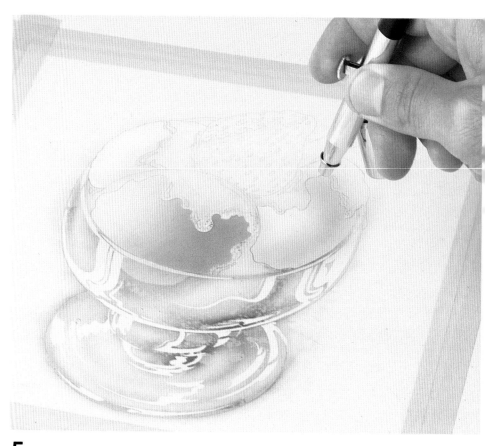

5 The goblet is now protected and the ice cream uncovered. Airbrush in the colors, taking care with the spherical aspect of the two balls.

7 When the caramel sauce is finished it is masked, and work begins on the strawberry. Pay attention to the shiny areas and cover them with masking liquid. Apply an intense red, giving volume and texture to the strawberry.

6 The ice cream is once again covered and the caramel sauce is painted. The glossy areas are masked while we place the color in this area.

An Ice Cream Sundae

8 Fine lines created with the airbrush have helped us begin to reproduce the texture of the ice cream, but this is not enough. Now color must be sprayed in the center of the ice cream to give the effect of its rippled surface. This is best applied with a toothbrush.

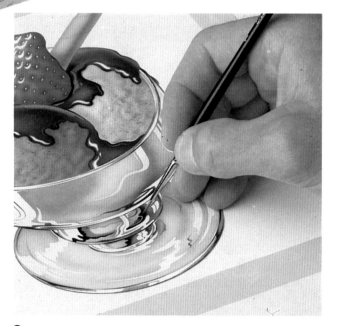

9 The exercise is almost finished. Dark areas, outlines, and other details are now added with the aid of a brush and colored pencils.

10 The finished illustration.

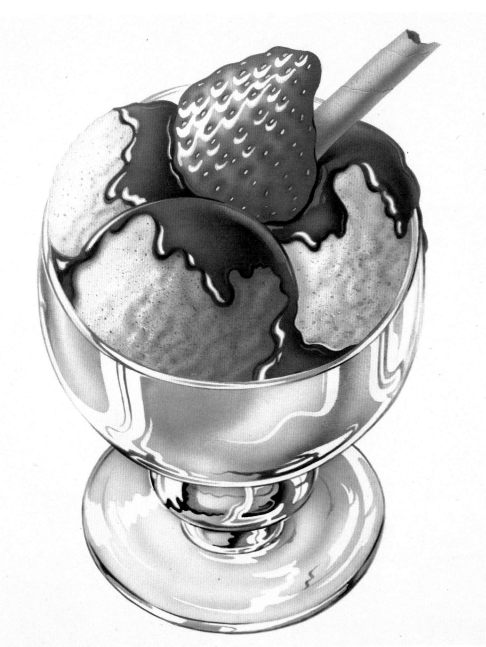

A Woman's Face

This exercise presents a few difficulties. There are two different but very well defined textures: the face and the hair. In both cases an ability to synthesize forms, volume, and gloss is required.

Liquid watercolors will be used for this subject, as they guarantee transparency and clarity in the finished work. There will also be an opportunity to practice manual application of the finishing touches.

1 As always, the work is begun by masking the whole area. We then uncover the shape of the hair. The fine gloss is studied and masking liquid applied with a brush to those areas to be covered.

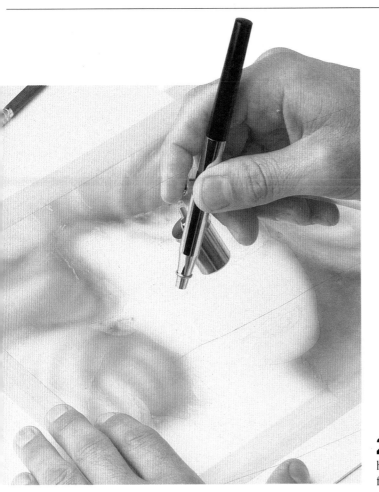

2 A suitable basic color is applied to the hair, which, at the same time, is given form.

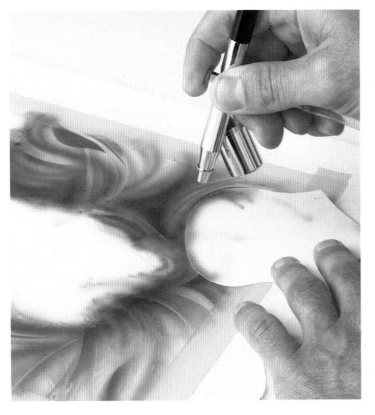

3 Curved stencils are used with a darker color to build up the hair.

A Woman's Face

4 When the masking liquid is removed, the gloss appears, but the contrast is too harsh.

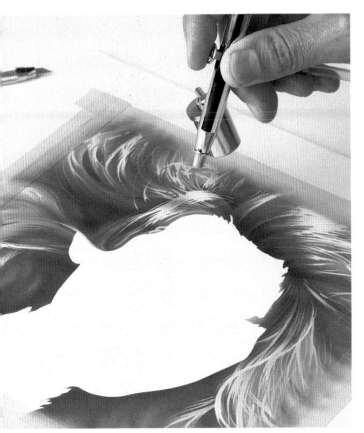

5 A soft golden tone eliminates the hardness and tones down the shine.

6 When the hair is finished it is masked, and work is begun on the base color of the face. The inside of the eyes and the shine on the lips must be protected with masking liquid.

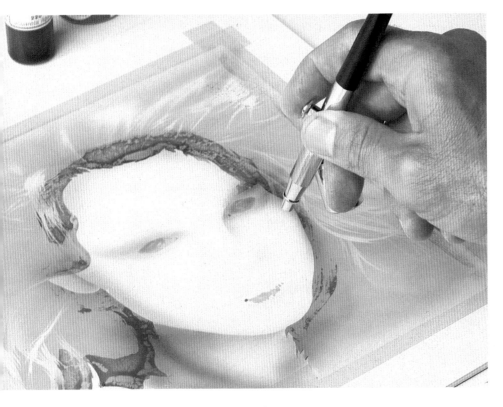

A Woman's Face

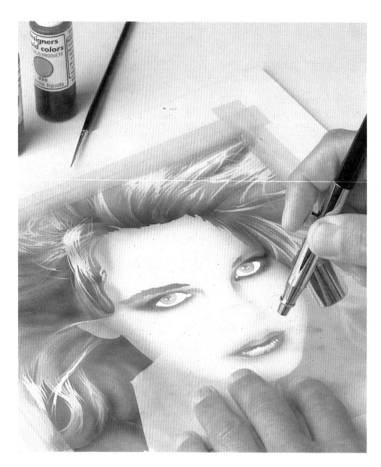

7 With stencils carefully placed, form and color are given to the eyes and lips.

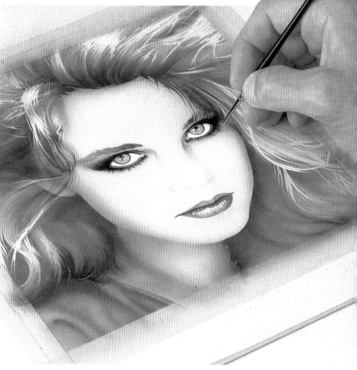

8 The finishing touches and added details are rendered with a brush and colored pencils.

9 The finished illustration.

Photographic Retouching

Photographic retouching has many different applications in the fields of both art and advertising, although more and more often the retouching is applied to give the effect of gloss or shades that the photographer has already anticipated. It is also very frequently used to produce photographic backgrounds where either a text or an image has to be removed or even added. In these cases, photographic retouching is absolutely necessary.

Although many of the details to be retouched are only small points that can be hidden or eliminated from the negative by the use of opaque red on the emulsion side, or scraped if they are in a transparent area, it is sometimes necessary to retouch the whole photograph because of the lack of quality of either the photograph itself or of the subject photographed (this was especially true a few years ago). In these cases the retouching is done on copies. It is necessary to cover almost the entire surface of the photo.

Very finely pigmented gouache colors are used for photographs that have to be reproduced and for artistic photographs that need special retouching. Gouaches are ideally suited to the airbrush, and are available in gloss or matte according to the type of paper used for the copy.

In the case under consideration, a printer's mold, the model has been photographed with all its imperfections. There is no solution other than eliminating all the stains and cracks that are visible. This will be done by airbrushing a copy. Bear in mind that to cover the photographic image, gouaches have to be used, that is, colorants that cover well. As the image will be reproduced, any type of finish, gloss or matte, can be used.

This is the process to be followed: mask the background, as only the mold is to be retouched. Base color is applied to all the surfaces by using a mobile stencil that will allow us to control the tone visually. The dark tones are emphasized in some areas and light tones in others, until the volume (perhaps exaggerated) suggested by the

copy is obtained. It must be remembered that as we are using opaque colors, we have to use a differently adjusted color each time, and not build up intensity simply by adding two or more coats.

Once the volume and the general details have been rendered, good retouching is needed to define the finish, the outline of the edges, and small areas that have disappeared under the coats of paint. A very

fine brush is used until the retouching is perfectly finished.

It is much easier to work with photographic enlargements (at least half as big again, for example) so that reproduction in a smaller size with the subsequent reduction of the image improves the effect and quality achieved during the retouching process.

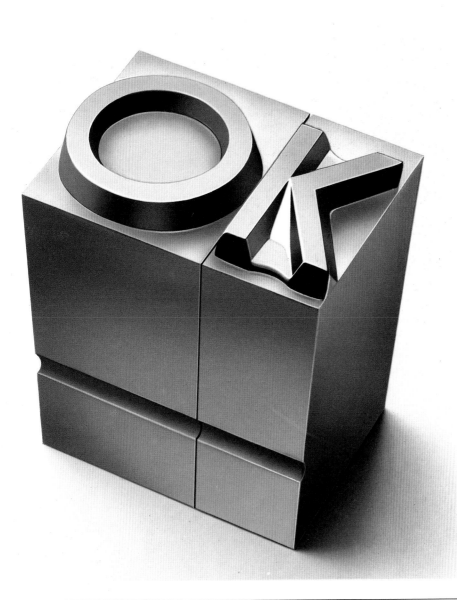

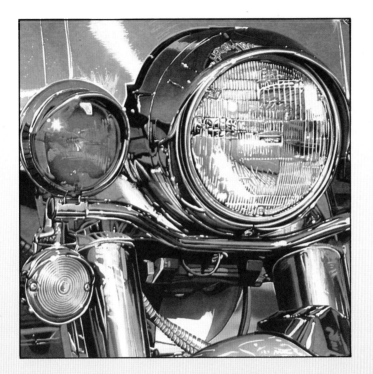

GALLERY

This gallery of examples has been compiled with the aim of collecting the widest possible range of styles in the field of airbrush illustration, be they purely artistic or representative of the more commercial aspects of art (that is, advertising design). In the following pages the reader will find excellent samples of airbrush techniques applied to graphic communication, as well as exceptional works executed by some of the best airbrush artists.

Fig. 1. Philippe Collier. The bright colors, the contrast between the different treatments of metallic parts, and the perfection of the final result demonstrate the artist's skill.

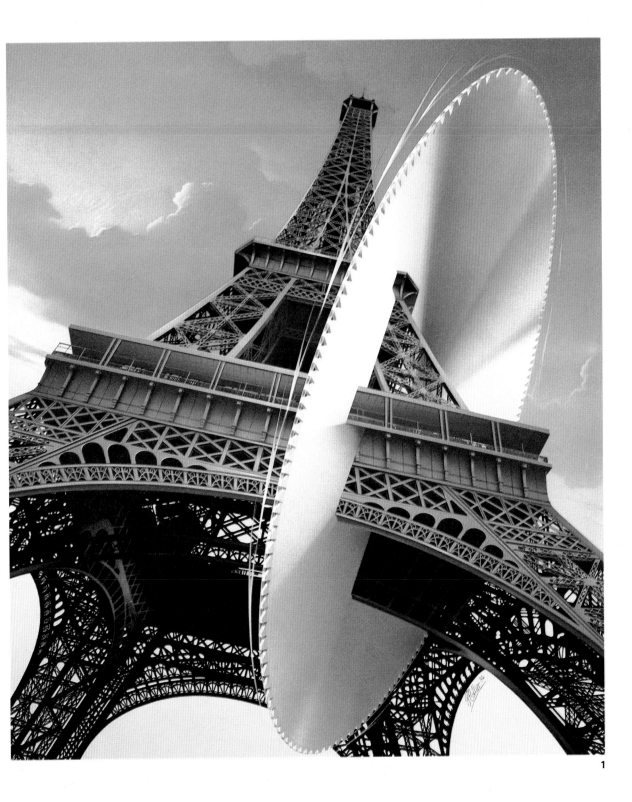

1

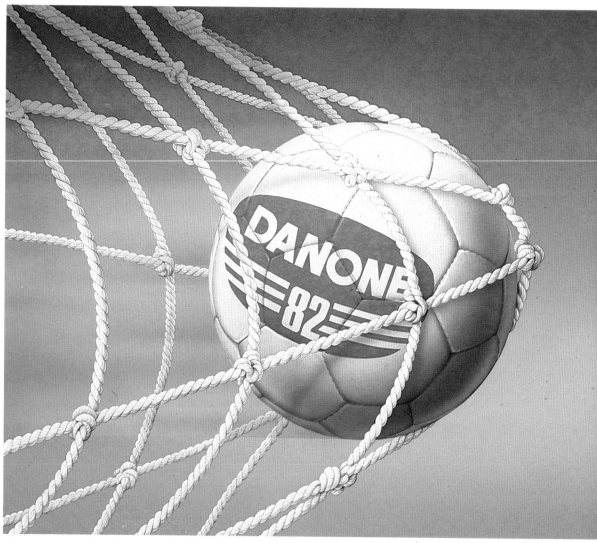

2

3

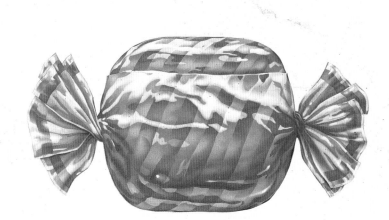

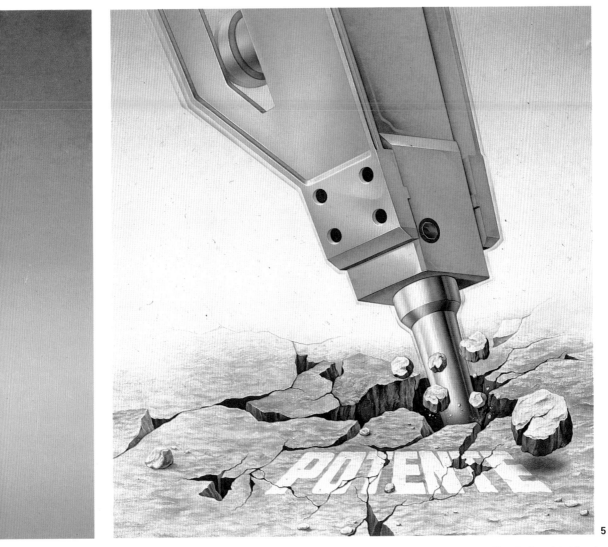

5

4

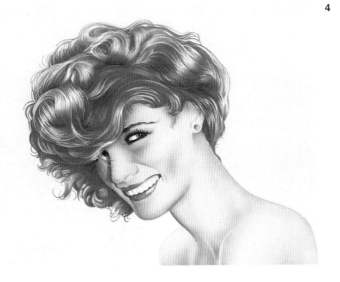

Figs. 2, 3, and 4. Miquel Ferrón. The quality of the leather, the detailed treatment of the rope, the shine and reflection given to the candy, and the rendering of the hair show the importance of the finishing touches.

Fig. 5. Miquel Ferrón. This is a characteristic example of the usefulness of the airbrush in shading and emphasizing volumes.

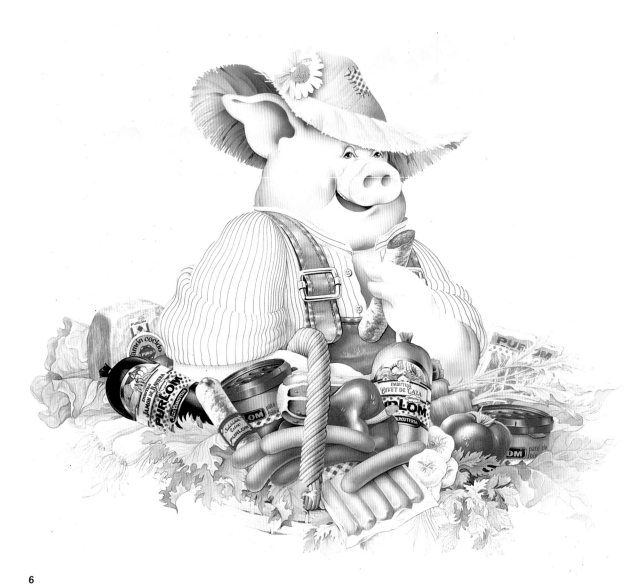

6

Figs. 6 and 7. Miquel Fe-
rrón. The complexities of
these two illustrations
present some specific
problems. Left: the great
variety of products in the
basket and their detailed
features require the use of
many different masks.
Right: in this advertise-
ment, a series of trans-
parencies has been super-
imposed to achieve the
bright, clear colors into
which light breaks down.

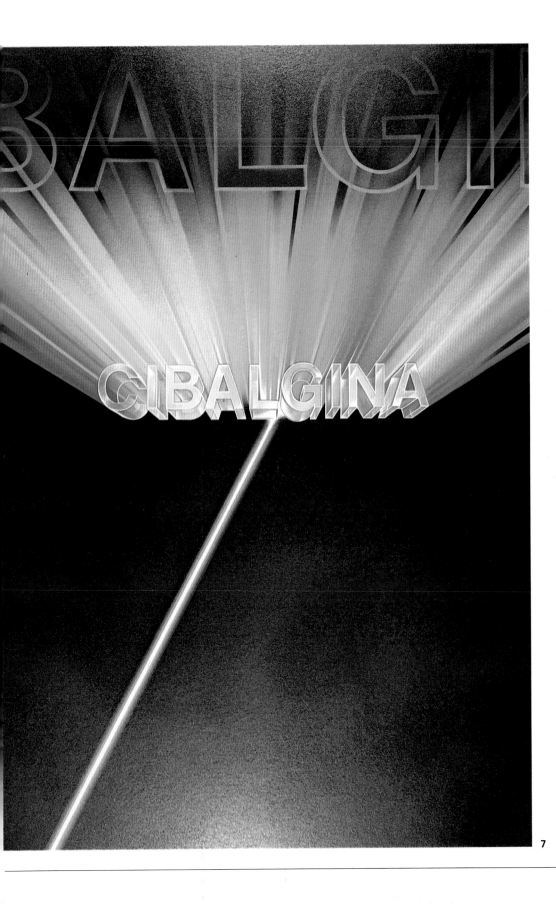

7

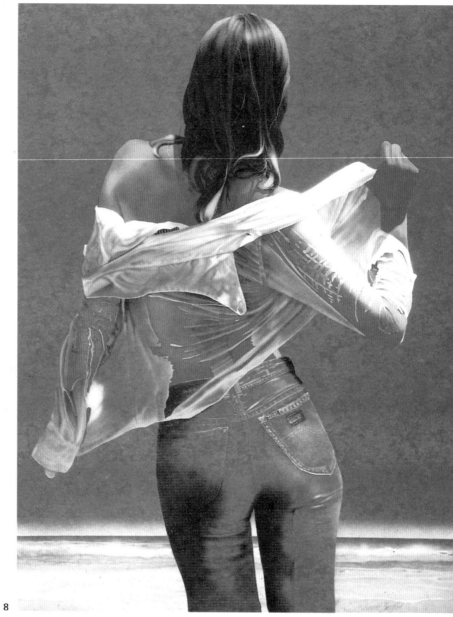

8

Fig. 8. Azman Yusof. This is an example of the airbrush application in the rendering of different textures, from blue jeans to a transparent blouse.

Fig. 9. Hideaki Kodama. This work perfectly demonstrates how to contrast metallic shine with dark colors.

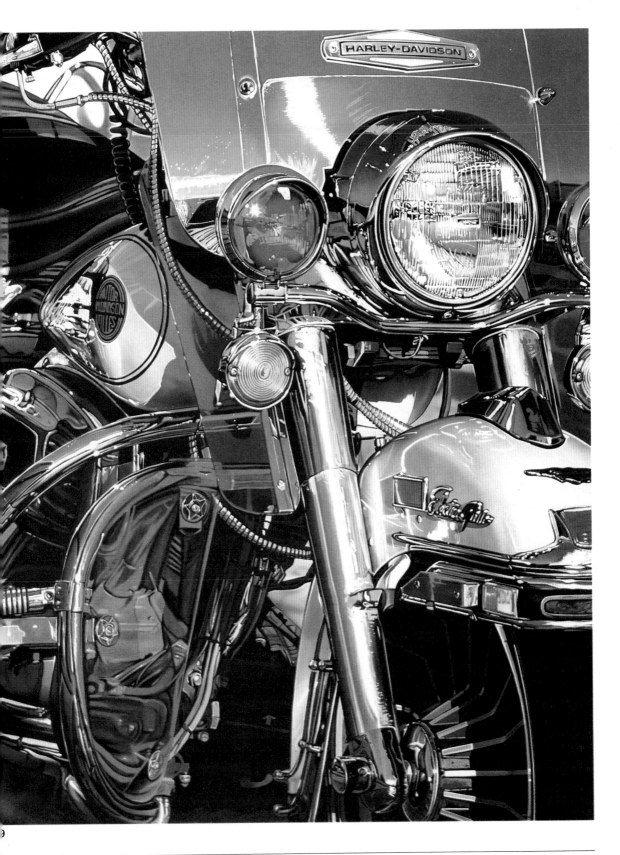

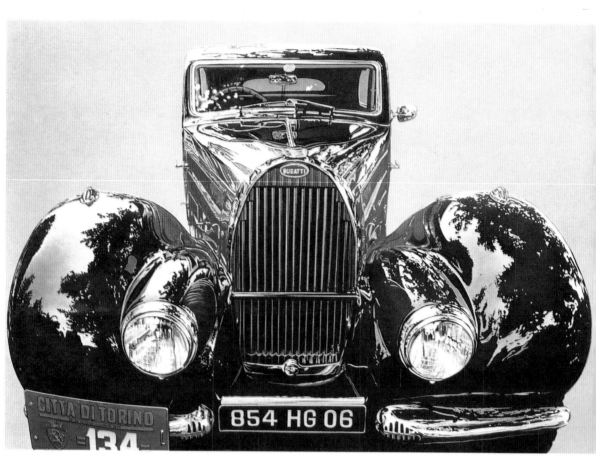

10

Fig. 10. Hideaki Kodama.
With this magnificent re
production of a Bugat
painted with the airbrush
Kodama shows us h
incredible ability in the in
terpretation of metalli
surfaces. The result is fu
of color and contrast.

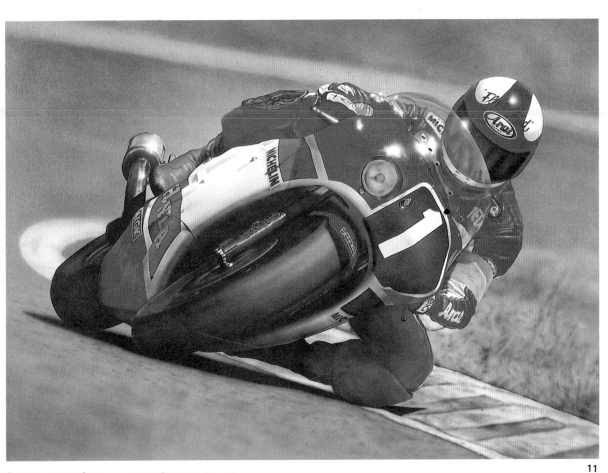

11

Fig. 11. Junpei Ogawa. Ogawa based this super-realistic illustration on a photograph; the shading, volume, contrasting vivid colors of the motorist, and the vague background give the effect of speed the artist has chosen to emphasize.

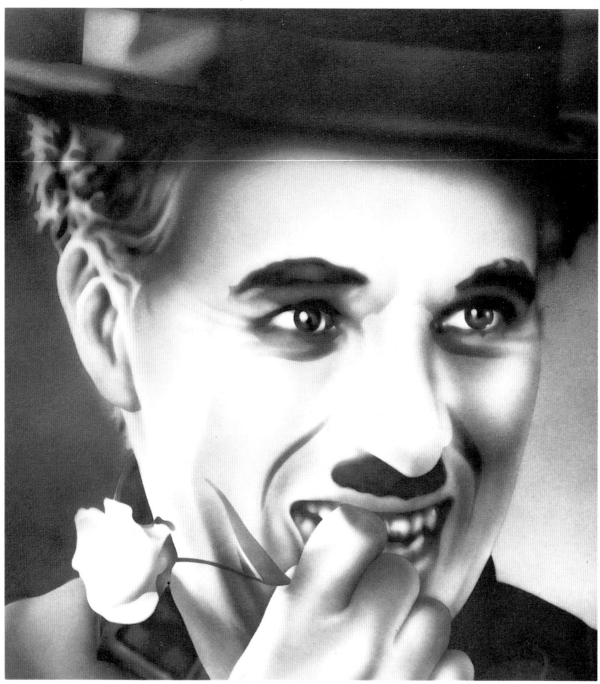

12

Fig. 12. Van Y. C. So. In this magnificent monochromatic portrait of Charlie Chaplin, the definition and the contrast used by the artist simulate the effect of a photograph taken many years ago. Figs. 13 and 15, Susumu Mochizuka; Figs. 14 and 16, Shen-Wu Ho. The particular sensibility of these images is the result of the excellent contrast between the treatment of the backgrounds and the colorful, detailed objects in the foreground.

13

14

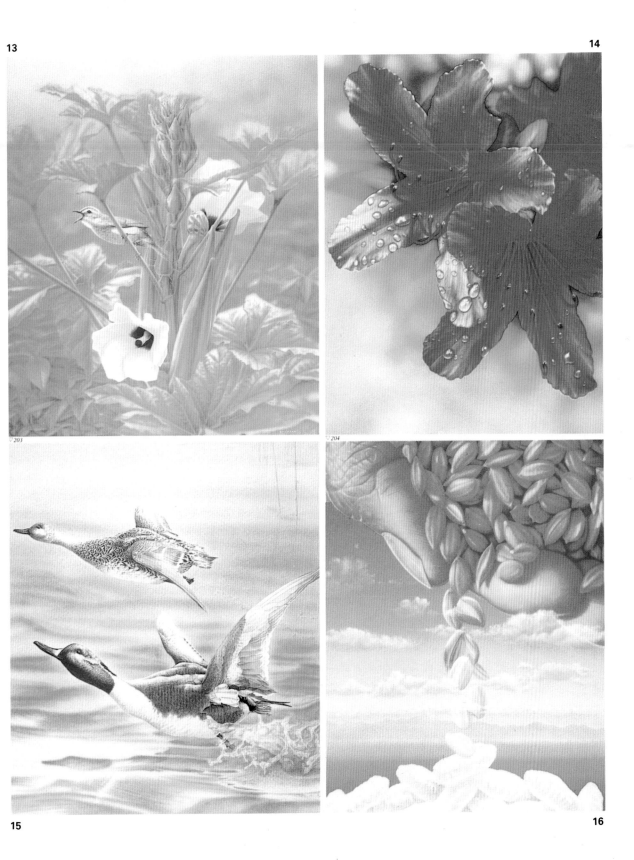

▽203

▽204

15

16

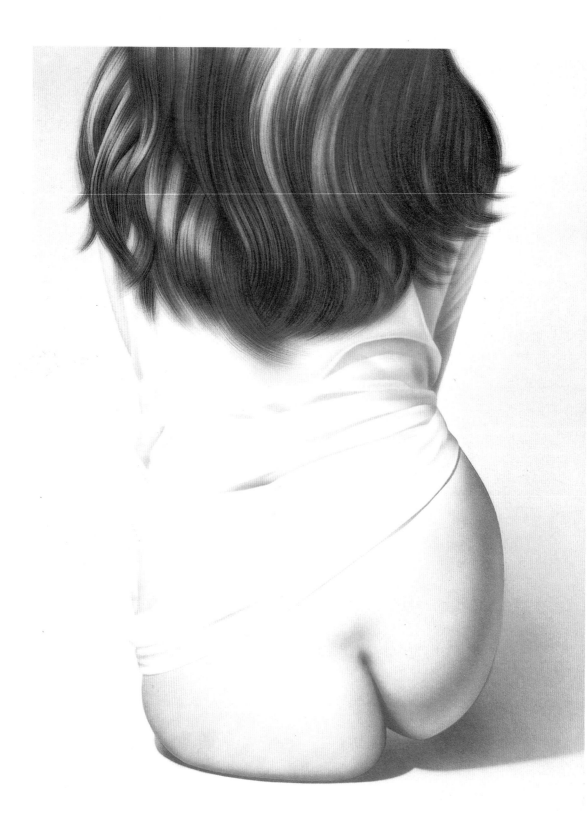

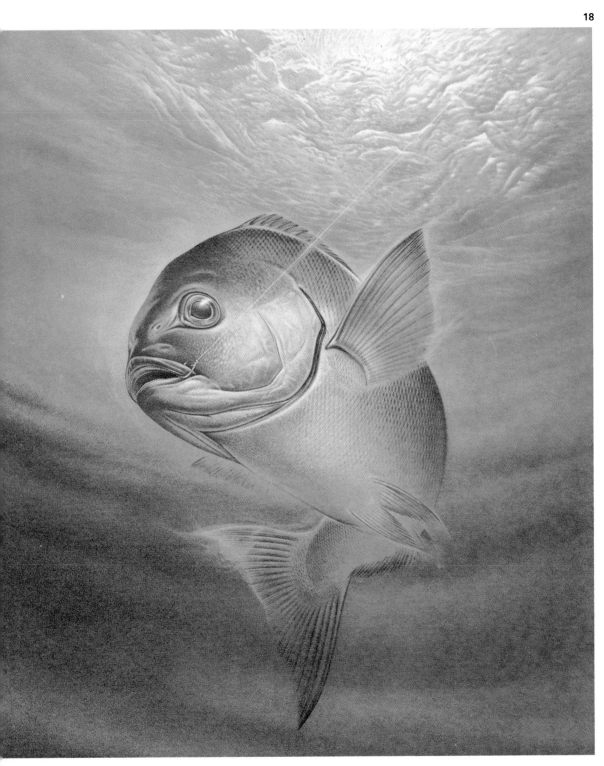

Fig. 17. Yosuke Ohnishi. This is a good example of shape and volume, enhanced by the contrast between the hair and the back. Note the perfect definition of the hair, accomplished with a brush.

Fig. 18. Shiro Nishiguchi. This work demonstrates some of the special effects obtained with the airbrush.

Fig. 19. Dennis T. Mukai. The main characteristic of this illustration is not its technical difficulty, but the simplicity and synthesis of its shapes.

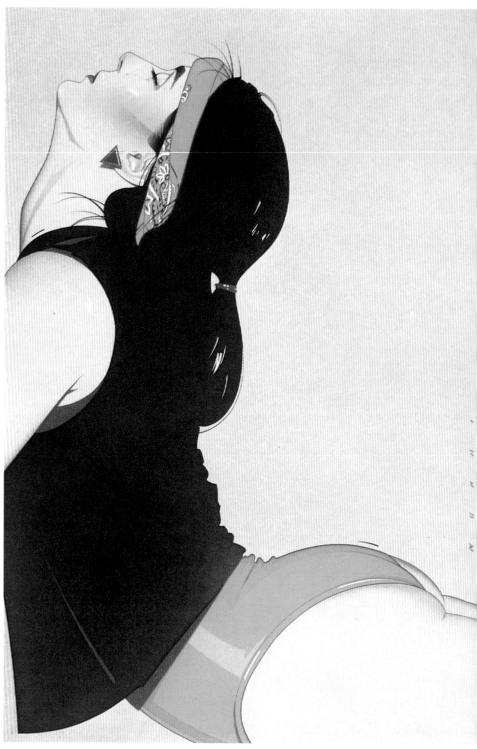

19

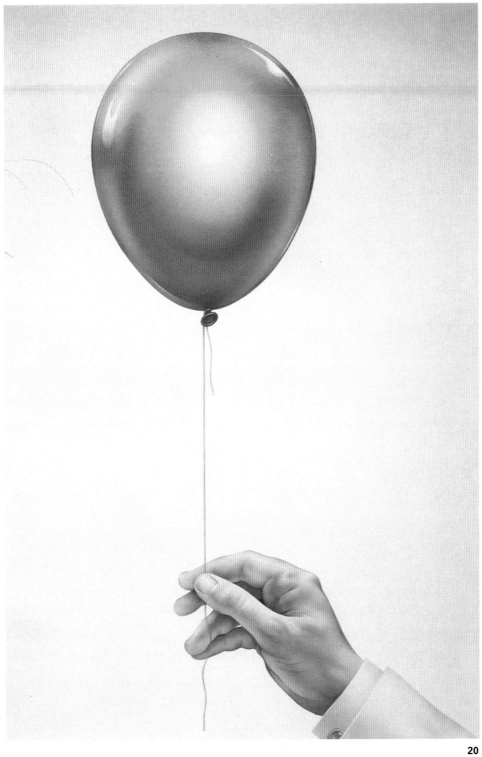

Fig. 20. Miquel Ferrón. This is a good example of defining a subject and rendering its texture exclusively with the use of an airbrush.

20

Fig. 21. Chris Moore. There are several special characteristics here: the artist's creativity in imagining the spaceship, the great contrast of colors, and an excellent use of the airbrush.

Fig. 22. Toshikuni Ohkubo. A wonderful effect and a perfect definition of an absolutely superrealistic image, based on a photograph taken in a few thousandths of a second. It is a thorough, detailed work in which colors and shapes have been masterfully interpreted.

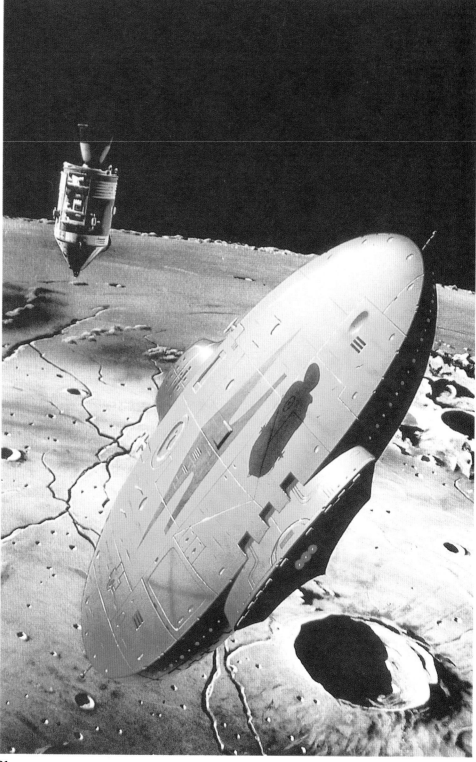

21

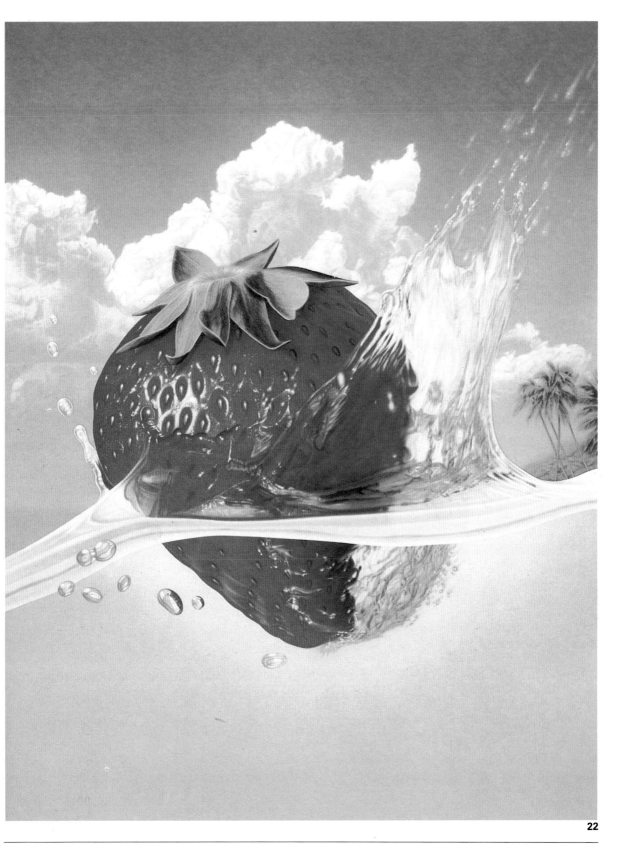

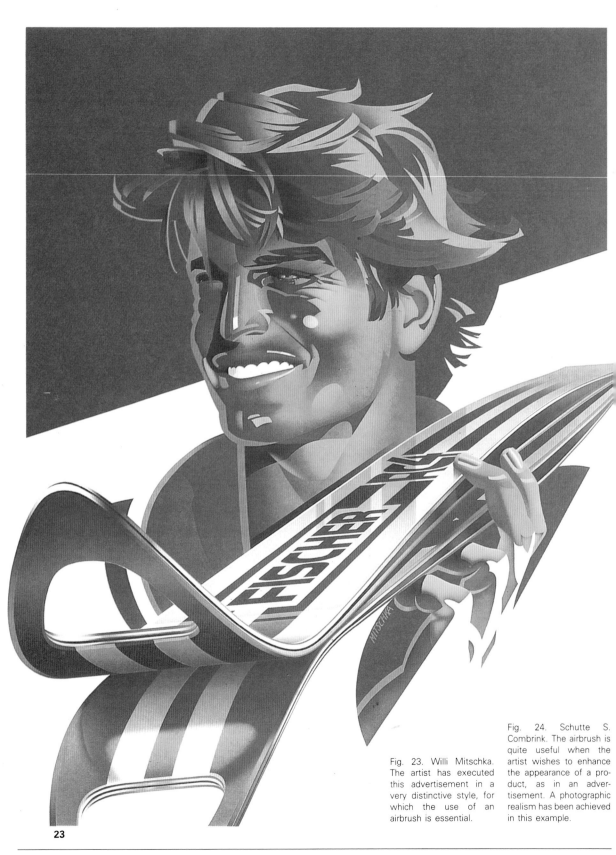

Fig. 23. Willi Mitschka. The artist has executed this advertisement in a very distinctive style, for which the use of an airbrush is essential.

Fig. 24. Schutte S. Combrink. The airbrush is quite useful when the artist wishes to enhance the appearance of a product, as in an advertisement. A photographic realism has been achieved in this example.

23

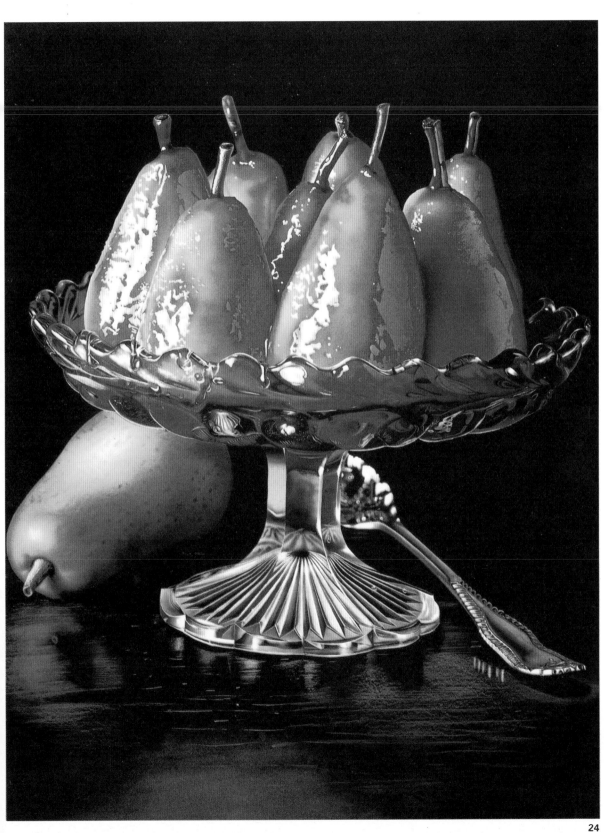

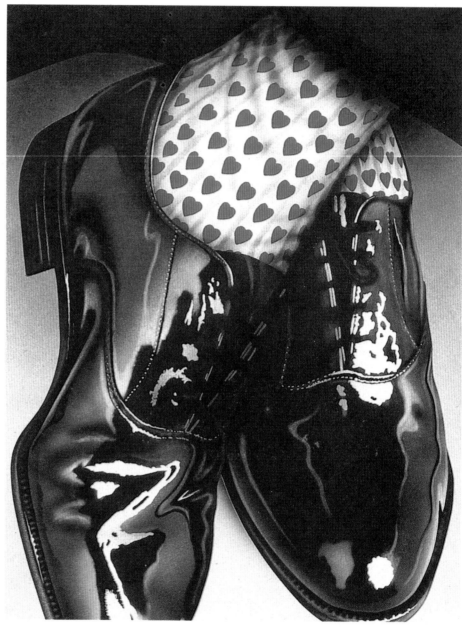

25

Fig. 25. Howard Robinson. The high graphic quality evident here is the result of a previous and detailed study of the model. The reflections have been exaggerated to maximize their luminosity.

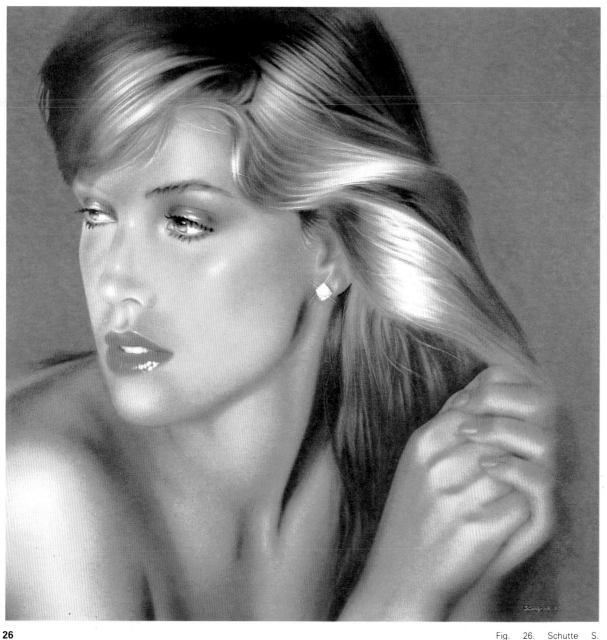

26

Fig. 26. Schutte S. Combrink. As we have already seen, the rendering of a woman's face requires the ability to define different textures, for example, a certain softness for the hair. The finishing details and touches for the eyes and lips are applied with a brush or colored pencils.

Acknowledgments

We would like to thank the following artists for allowing the reproduction of the illustrations included in this book:

Page 91
Philippe Collier
28 Av. des Lilas
59800 Lille, France

Pages 92-95
Miquel Ferrón
Espronceda, 300, 1.°, 2.ª
08018 Barcelona, Spain

Page 96
Azman Yusof
Creative Enterprise Sdn. Bhd.
11A-3 Bangunan UDA
Jalan Pantai Baru 56200
Kuala Lumpur, Malaysia

Pages 97 and 98
Hideaki Kodama
Spoon Co., Ltd.
3F Minami, 5-gokan Takahashi Bldg.
3-6-35 Nishitenma, Kita-Ku
Osaka 530, Japan

Page 99
Junpei Ogawa
JCA (Japan Creators' Association)
Umehara Bldg. 3 & 4 Floor
3-1-29 Roppongi, Minato-Ku
Tokyo, Japan

Page 100
Van Y. C. So
First Institute of Art & Design
195-197 Johnston Rd., 3 & 4 Floor
Hong Kong

Page 101
Susumu Mochizuka
Mochizuka Susumu Studio
202 Zingumae, Kanbara Mansion
6-3-43 Zingumae, Shibuya-Ku
Tokyo 150, Japan

Page 101
Shen-Wu Ho
Lemon Yellow Design Association
9th FI No. 512
Chung-Hsiao E. Rd.
Sec. 4, Taïpeh
Taiwan (ROC)

Page 102
Yosuke Ohnishi
3B Yuki Flat
1-14-15 Nishiazabu, Minato-Ku
Tokyo 106, Japan

Page 103
Shiro Nishiguchi
Spoon Co., Ltd.
3F Minami, 5-gokan Takahashi Bldg.
3-6-35 Nishitenma, Kita-Ku
Osaka 530, Japan

Page 104
Dennis T. Mukai
JCA (Japan Creator's Association)
Umehara Bldg. 3 & 4 Floor
3-1-29 Roppongi, Minato-Ku
Tokyo, Japan

Page 105
Miquel Ferrón
Espronceda, 300, 1.°, 2.ª
08018 Barcelona, Spain

Page 106
Chris Moore
14 Ham Yard
London W1, England

Page 107
Toshikuni Ohkubo
JCA (Japan Creators' Association)
Umehara Bldg. 3 & 4 Floor
3-1-29 Roppongi. Minato-Ku
Tokyo, Japan

Page 108
Willi Mitschka
Dustmannweg, 39
A 1160 Vienna, Austria

Pages 109 and 111
Schutte S. Combrink
P.O. Box 84010
Greenside 2034, South Africa

Page 110
Howard Robinson
Michael Woodward Associates
Artists Agent & Art Library
Barkston Towers Barkston Ash
Tadcaster LS24 9PS
North Yorkshire, England